PAST & PRESENT

SANDY HOOK

Enjoy Discovering The Hook!

John Sch— 2021

SANDY HOOK

John Schneider

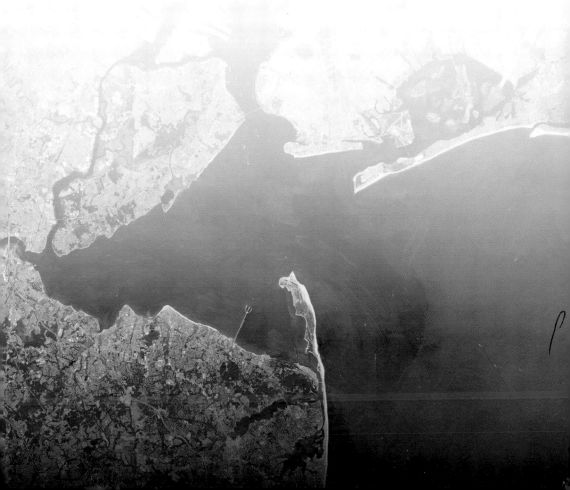

Dedicated to all those who tamed the wilderness of the ever-changing spit of land called Sandy Hook.

Copyright © 2021 by John Schneider
ISBN 978-1-4671-0680-1

Library of Congress Control Number: 2021936433

Published by Arcadia Publishing
Charleston, South Carolina

Printed in the United States of America

For all general information, please contact Arcadia Publishing:
Telephone 843-853-2070
Fax 843-853-0044
E-mail sales@arcadiapublishing.com
For customer service and orders:
Toll-Free 1-888-313-2665

Visit us on the Internet at www.arcadiapublishing.com

ON THE FRONT COVER: The observation balloon seen here around 1919 was used to look for enemy ships on the horizon. Some sensational 16mm film was also shot from the balloon while it floated over Fort Hancock. Dozens of soldiers were involved with inflating the balloon and then guiding it from its special hangar. The straw basket hanging from it could hold several passengers; below, a group of soldiers would hold onto ropes to keep it from floating away. It was the same technique used today with floats in the Macy's Thanksgiving Day Parade in New York City. (Past image, courtesy of US Army Center for Military History; present image, courtesy of Geri Gray.)

ON THE BACK COVER: The lighthouse on Sandy Hook was built in 1764 to help guide the increasingly frequent traffic from Europe to New York Harbor. Because it was easily seen, it was camouflaged in 1942 to prevent attacks. Today, the steps inside the lighthouse may be climbed for a spectacular 360-degree view of Sandy Hook. (Courtesy of the National Archives.)

CONTENTS

To
Mike

Many of the
contemporary photos are done
by me. Enjoy using the book to
find out more about "the Hool"

Glen

ACKNOWLEDGMENTS

Thanks go to Geri Gray, who took many of the contemporary photographs of Sandy Hook seen in this book. Her persistence to get just the right shot at the perfect angle and during the best time of day made this book so much better.

Shawn Welch, retired US Army colonel and board member of the Army Ground Forces Association (a philanthropic partner of the National Park Service at Fort Hancock), provided extraordinary support and has informed me about Sandy Hook's importance to American defense policy across the nearly 150 years of its existence as a military installation and what life may have been like on Sandy Hook when thousands of soldiers occupied the installation. He also spent considerable time editing and assuring the accuracy of both the text and photographs.

Tom Minton was instrumental in helping to improve my knowledge of Sandy Hook's military presence and assisting me in editing the descriptions of the photographs for better clarity and accuracy. He also trudged with me through sand and weeds to locate hard-to-find historic structures.

Pete McCarthy, Jennifer Cox, and Tom Hoffman, along with other staff members of the National Park Service, have done an admirable job in meeting the challenge of preserving and promoting a national historic landmark where thousands of visitors come to play. Their assistance in assuring the accuracy of the contents of this book is greatly appreciated.

Monmouth County Archives and the Monmouth County Park System always support my efforts in trying to tell a complicated story.

Thanks to the following organizations and individuals that have either inspired me or provided information to help produce this important record of our historical past: Aberdeen Proving Grounds Archives, Randall Gabrielan, Thomas Hoffman, Cory Newman, National Aeronautics and Space Administration (NASA), National Archives and Records Administration (NARA), New Jersey Archives, John Rhody collection, Sandy Hook Foundation (SHF), the US Army Heritage and Education Center (USAHEC), US Army Center for Military History (CMH), US Coast Guard (USCG), and the National Park Service, Gateway National Recreation Area Archives (GATE).

Arcadia Publishing, represented by Stacia Bannerman and Katelyn Jenkins, always embellishes my ability to make sense and get my books into the marketplace.

Finally, thanks so much to you for reading this book and helping to keep the spirit of Sandy Hook alive. Your continued support throughout the years has kept me positive and upbeat in my attempt to document and bring to life the glorious history of a very special area.

INTRODUCTION

Sandy Hook, New Jersey, is an amazing place with an amazing story to be told. It is a six-and-a-half mile barrier spit surrounded by water on three sides: the Atlantic Ocean, the Shrewsbury River, Sandy Hook Bay, and Raritan Bay.

Geologically, spits are a narrow coastal land formation connected to the mainland, or coast, at one end. Like a peninsula, spits frequently form where the coast abruptly changes direction, often across the mouths of tidal estuaries. It is not surprising, therefore, that the Navesink Estuary flows into the Sandy Hook spit on the landward side.

Spits, often comprising beach sand, are formed by the movement of sediment through the action of waves, tides, and weather. There are thousands of spits throughout the world.

The longest spit is the Arabat Spit in the Sea of Azov, which is almost 70 miles long. The Sea of Azov, connected to the Black Sea by the narrow Strait of Kerch, is bounded in the northwest by Ukraine and in the southeast by Russia. The longest spit in freshwater is the Long Point Spit in Canada, which extends about 20 miles into Lake Erie.

Giovanni da Verrazano was the first European to explore the Atlantic coast of North America, making his way into Raritan and Sandy Hook Bays by 1524. Soon thereafter, a few maps were created to help guide the way. Henry Hudson discovered Sandy Hook around 1609, and following him, the Dutch came in droves. In fact, the name Sandy Hook comes from the Dutch *sant hoek*, which means a spit of land.

In the early days, there was no safe deep-water channel coming in and out of New York Harbor. The only way into the harbor required ships to head straight for the tip of Sandy Hook and then make a hard right. In the days of sailing ships, if sailors missed that turn during a storm and did not know exactly where they were, they could end up on one of many shoals or sandbars below the surface of the water. As a result, there are hundreds of shipwrecks near that critical turning point at the tip of Sandy Hook.

Nevertheless, there was an influx of immigrants and merchants, and unfortunately, some of them were shipwrecked just as they were arriving. As a result, both lives and merchandise were lost.

Many of the original thirteen colonies owned by England eventually built lighthouses for commercial reasons. The merchants had filled ships with goods needed by the colonies, so they wanted their merchandise to arrive safely at a dock or wharf in what would eventually be known as New York City.

By the time the American Revolution against the British started in 1775, there were only 11 lighthouses in the colonies. The first built was Boston Lighthouse, the second was on Nantucket Island, the third was erected at the entrance to Narragansett Bay in Rhode Island, and the fourth was in New London, Connecticut. The lighthouse on Sandy Hook was the fifth to be constructed in the colonies.

Sandy Hook was low and flat, and so even on a clear day, one could not see the spit from the sea. That is why, by 1764, the colony of New York built a lighthouse so that ships could sail safely into New York Harbor. It was originally called New York Lighthouse because it was funded through a New York assembly lottery and from taxes collected from all ships entering the port of New York.

Of the 11 lighthouses originally built by the colonies, only one still stands: Sandy Hook Lighthouse. The builder was Isaac Conroe, who lived in New York City and constructed buildings for a living. He also sold building materials to those early settlers and businesses wishing to put down roots.

The lighthouse on Sandy Hook has weathered well over the centuries because care was always taken to assure its survival. Also, when the lighthouse was new and located at the very tip of the hook (about 500 feet from the shore), it was subject to the ferocity of ocean waves during severe storms. However, as more and more sand built up along the shoreline, the lighthouse became located further and further from the ocean. With more land surrounding the lighthouse, it became more protected from the ocean waves.

Spits are also notorious for changing their shape over time due to tides and weather. The Sandy Hook Spit is no exception. Because this specific area of the New Jersey shore has experienced a considerable number of hurricanes and nor'easters in the past, the Sandy Hook spit provides some protection from the storm surges that have threatened nearby towns, such as Highlands and Atlantic Highlands, New Jersey.

While both the geology and ecology of Sandy Hook are interesting, the military and civilian history of Sandy Hook for the past couple hundred years are even more fascinating, from one of the earliest forts (the design of which was approved by a young Robert E. Lee) to defending New York City from naval threats.

The War of 1812 had a profound effect on the future of Sandy Hook. The British attack upon our young nation's harbors left a lasting impact on national leadership. In 1813, Congress authorized the secretary of war to purchase land for fortifications at all major harbors. That year, the Army initiated the purchase of the entirety of Sandy Hook. That purchase was completed in 1814.

The first permanent fortification construction began in 1850 to protect both seaborne commerce and the Navy. From 1874 to 1919, the US Army Ordnance Department operated the Sandy Hook Proving Ground on Sandy Hook to test all major Army weapons. In the late 1880s, the Army began constructing comprehensive harbor fortifications to protect New York from threats. This continued at Sandy Hook in various forms until the Army closed Fort Hancock in 1974 and transferred the property to the Department of the Interior (National Park Service) in 1975.

Today, all of Sandy Hook remains US government property. It is owned and managed by the National Park Service and the Department of Homeland Security (US Coast Guard). Coast Guard Station Sandy Hook is closed to the public due to the sensitive nature of its mission. The Department of the Interior manages a large portion of Sandy Hook as the Sandy Hook Unit of Gateway National Recreation Area.

Since 1975, an average of two million tourists and beachgoers come to the Sandy Hook Unit every year to spend an afternoon on one of its many beaches, to hike or cycle on several footpaths, or to explore relics from its past, such as the lighthouse or more than century-old artillery batteries.

The entirety of Sandy Hook was designated in 1984 as the Fort Hancock and Sandy Hook Proving Ground National Landmark District by the secretary of the interior. This is the highest level of federal recognition for a nationally important historic location.

Sandy Hook has become a living museum, and so we should all be respectful of every rusted piece of metal or broken piece of concrete. It is, after all, a federal offense to deface or remove anything from the peninsula. If you must take something, take photographs.

Marshes, storms, poison ivy, holly forests, and shifting sand along the coastline of Sandy Hook made overcoming the wilderness a challenge. Over the years, train tracks and dirt roadways became today's pathways, bicycle trails, and paved roads.

The physical evolution of Sandy Hook has been a dramatic story for hundreds of years. The spit's ever-changing shape, influenced by currents, storms, and wind, has caused some structures built close to the shore to be washed out to sea or buried in the sand, while ships trying to enter Raritan Bay had to be on the lookout for newly created shoals and sandbars.

While concrete mortar was invented centuries ago, its further development and utilization were the mainstay of materials used at Fort Hancock for buildings, utilities, and fortifications, and the proving ground facilities. There was so much concrete used in the construction of gun batteries, a temporary plant was built to manufacture it at Sandy Hook. Today, many of the structures built of concrete are beginning to show the passage of time, as seen in this book.

While this book is not meant to be completely historical, hopefully, it will provide some perspective on what remains half-buried in the sand as relics, and a better understanding of the significant role Sandy Hook played in our country's evolution.

TAMING CURRENTS OF TIME

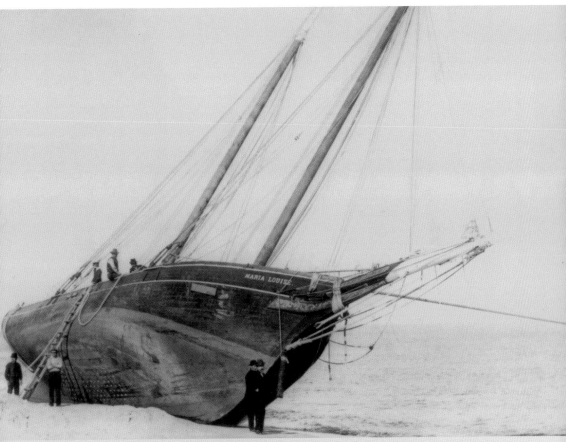

Ever since the early explorers, traders, settlers, and eventually, immigrants started crossing the oceans in their ships to reach the New World, approaching Sandy Hook was one of the last challenges before arriving in the relatively safe waters of Raritan Bay. The sands were continually shifting underwater, the currents were strong, and there were few signs of how to navigate past the tip of Sandy Hook. As a result, there were thousands of shipwrecks just like the one shown here on Sandy Hook. (Courtesy of the National Archives.)

For centuries, a natural, narrow, deep-water channel has been close to the tip of Sandy Hook. While it may seem counterintuitive for ships to sail so close to land, experienced captains used this channel to enter New York Harbor. By the 1880s, the channel was regularly dredged and included on navigational charts. Today, the channel is clearly marked, so ships can easily maneuver past the tip and into Raritan Bay with cargo or passengers. It is always an extraordinary sight to see ships pass so close to the beach, like the one shown above, because one would expect them to crash into the shoreline. (Past image, courtesy of the National Archives; present image, courtesy of Geri Gray.)

TAMING CURRENTS OF TIME

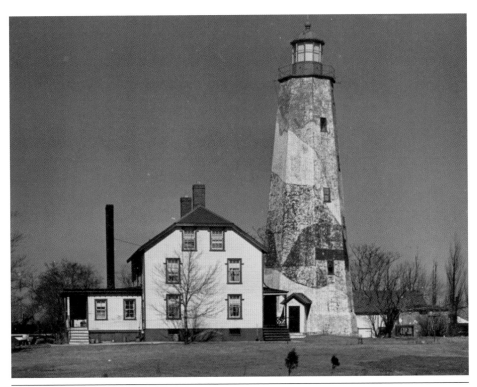

Ironically, the oldest structure on Sandy Hook has changed the least. Built in 1764 to help guide ships past the tip of the peninsula and into Raritan Bay, it remains the oldest continuously operating lighthouse in America and is listed in the National Register of Historic Places. As shown above, painted in camouflage in 1942, it could have been an easy target if left white. When first completed, the lighthouse was only 500 feet from the tip of the hook. However, because of storms, wind, and currents, the sand comprising Sandy Hook has continually changed the landscape. By 1864, the northern tip of Sandy Hook was more than three-fourths of a mile from the lighthouse. Today, the lighthouse is about one-and-a-half miles from the tip (Past image, courtesy of the National Archives; present image, courtesy of Geri Gray.)

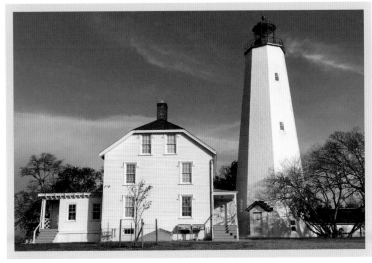

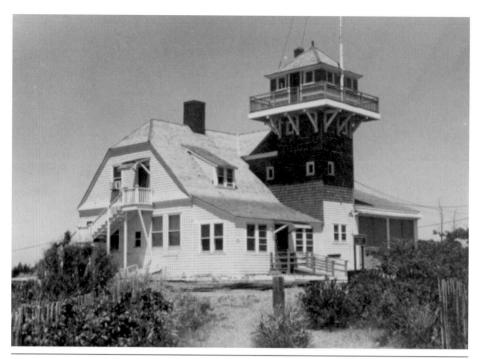

While the lighthouses and beacons helped guide ships to port, it was not always easy to navigate the channel. The US Life-Saving Service began in 1849 because of the many shipwrecks along the East Coast. The lifesaving station shown here, located on the beach midway up Sandy Hook, became the National Park visitor center until Hurricane Sandy made the building uninhabitable. The damaged building, erected in 1894, is currently being rehabilitated. (Past image, courtesy of New Jersey Archives; present image, courtesy of Geri Gray.)

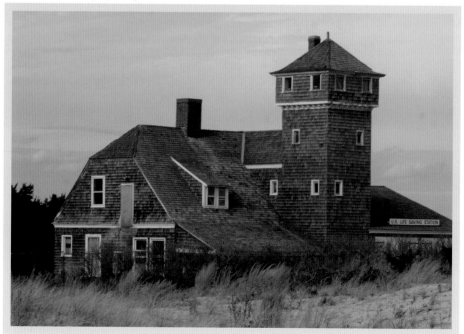

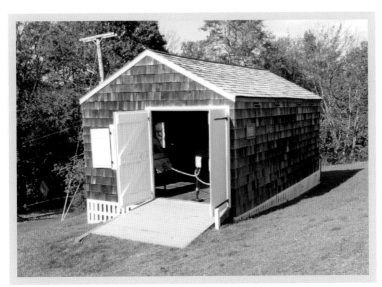

Prior to lifesaving stations, which were located along the coastline, lifesaving sheds such as the one seen below around 1920 were more ubiquitous and contained the necessary equipment to rescue passengers and crews of ships in distress. Most of the sheds were removed by the US Life-Saving Service and replaced with bigger and better buildings and improved equipment as the US Coast Guard provided more modern rescue operations. The only surviving shed (above) was relocated from Sandy Hook to the Twin Lights of Navesink in 1954, where it was restored and today may be seen with some of the actual equipment used to save lives. (Past image, courtesy of Twin Lights Historical Society; present image, author photograph.)

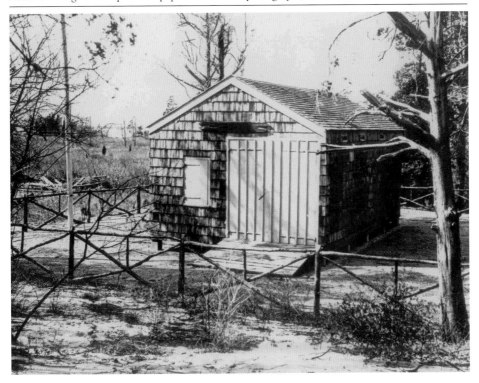

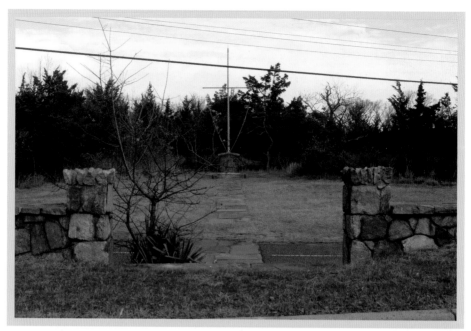

When the Revolutionary War ended in 1783, one of the last British ships in America was preparing to leave Sandy Hook Bay, but several crew members deserted the ship and fled to Sandy Hook. One of the ship's officers, Hamilton Douglas Halyburton, and a search party all died during a severe blizzard. Today, a monument stands near the cove where the bodies were eventually found and the ship had been anchored. The below photograph was taken in 1938. (Past image, courtesy of GATE; present image, author photograph.)

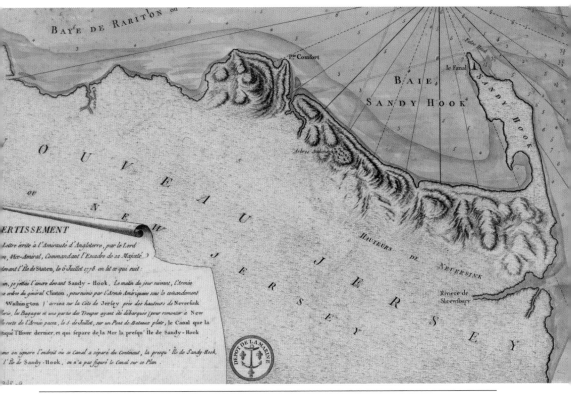

During the past hundreds of years, the generally contiguous seven-mile length of Sandy Hook was occasionally affected by storms that surged across the land from the Atlantic to create new channels and inlets, which allowed the ocean to flow directly into the Shrewsbury River and turn Sandy Hook into an island. This happened continually for hundreds of years as storms and currents changed the shape dramatically. The c. 1778 French map of Sandy Hook above shows Sandy Hook connected by a land bridge to today's Borough of Highlands. The c. 1886 map below shows Sandy Hook with its current shape. (Past image, courtesy of Library of Congress; present image, courtesy of G. Cook.)

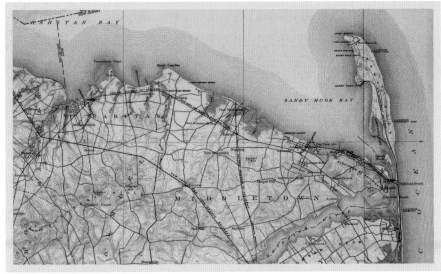

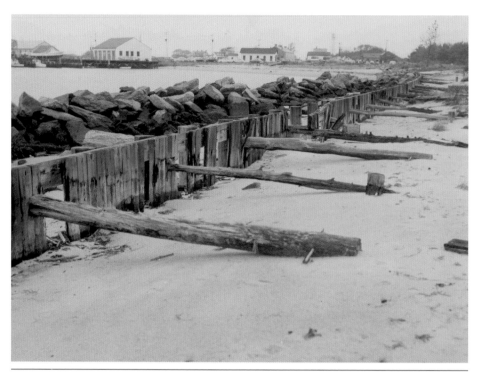

As civilization began to take over the wilderness of Sandy Hook, breakers, seawalls, and bulkheads were installed to prevent erosion of the land. From this view, one of the chapels in Fort Hancock can be seen in the distance. Regardless of any attempts to control the erosion of Sandy Hook, Mother Nature is always a formidable adversary. The current seawall will soon be replaced. (Past image, courtesy of GATE; present image, courtesy of Geri Gray.)

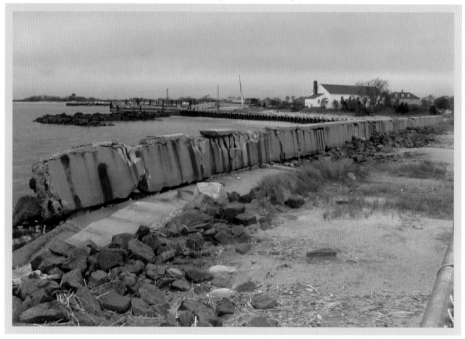

CHAPTER 2

TESTING WEAPONS OF WAR

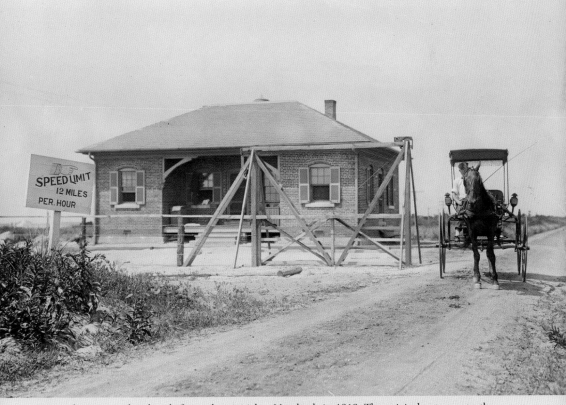

More than two decades before the initial Fortifications at Sandy Hook were renamed Fort Hancock, the US Army Ordnance Department was testing new and experimental weapons at the Sandy Hook Proving Grounds, which stood on Sandy Hook from 1874 until 1919. The weapons became so powerful and the explosive shells traveled so far, the proving ground had to be moved to Aberdeen, Maryland, in 1919. The original entrance to the proving grounds is seen here around the turn of the 20th century. The speed limit is clearly marked at 12 miles per hour, which happened to be the average speed of a horse and buggy. Today, traffic moves along the paved road at 35 to 45 miles per hour. (Courtesy of CMH.)

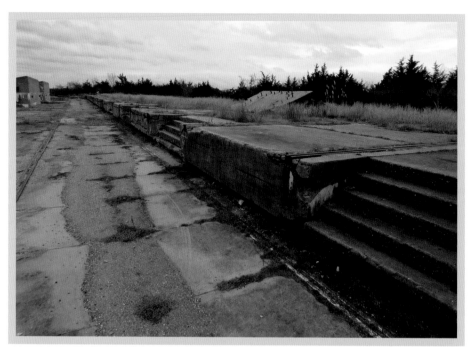

The proof battery (seen below in 1901), or firing line, was at the northeastern end of Sandy Hook and had a range of 3,000 yards south. For longer-range tests, guns were fired toward the ocean. Tests were made for gun tubes, gun carriages, gun powder, artillery shells, fuses, and primers. Many weapons were tested here regularly. Testing weapons was very often dangerous work that resulted in the death of both soldiers and civilians killed by weapons failures. "Proving" was all about stressing weapons to ensure they were safe. The challenge was protecting the testing team from the potential failure of the weapons. Protections improved over time, but testing was always inherently dangerous. (Past image, courtesy of GATE; present image, author photograph.)

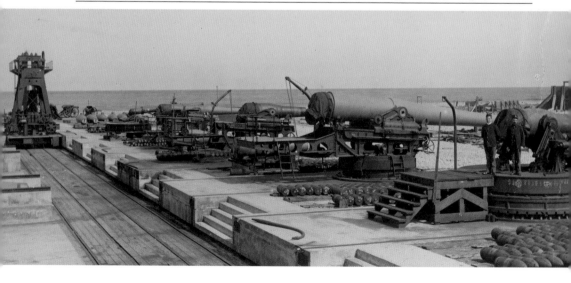

TESTING WEAPONS OF WAR

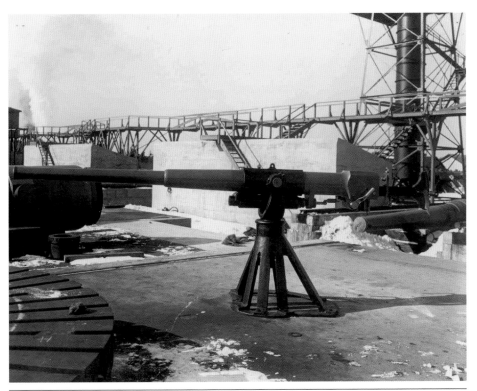

While the metal stairways and observation platforms shown above are gone, two of the large bombproof blocks still stand today. After several soldiers were killed during testing, these giant concrete blocks were built to shield the test operations buildings and the people in them from accidental explosions during a test firing. These fatalities were the first and only ones on Sandy Hook associated with military action. Very often, civilian scientists, engineers, and manufacturers would participate in the testing. Today, the proving grounds are listed in the National Register of Historic Places as part of the Fort Hancock and Sandy Hook Proving Ground National Historic Landmark District, which encompasses the entirety of Sandy Hook. (Past image, courtesy of CMH; present image, author photograph.)

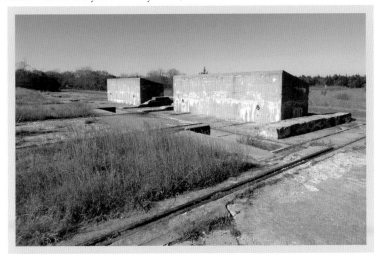

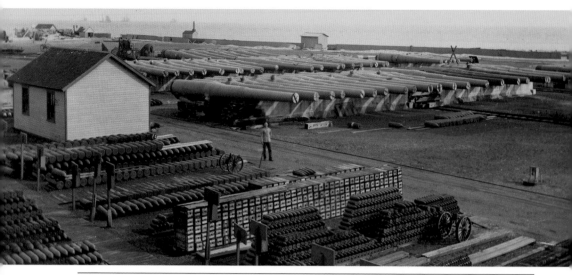

The "gun park," adjacent to the proof battery, was where gun barrels, shells, and other weapons components were stored before being tested. Every single weapon, and every part associated with weapons, had to be tested. Today, as seen below, the location contains a couple of partially exposed buildings and three large "barrel skids" that once supported the proof battery, but it is mostly an empty field. New weapons to be tested arrived regularly by ship at the loading dock, where they were lifted onto a train that carried them to this location. (Past image, courtesy of GATE; present image, author photograph.)

TESTING WEAPONS OF WAR

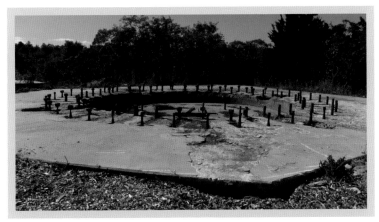

In 1916, two turrets mounting two 14-inch guns (shown below) were fired from a specially constructed test block several hundred yards away from the actual proof battery. The two gun turrets were headed to Fort Drum in the Philippines. Park historian Tom Hoffman advised the Army Ground Forces Association (AGFA) recently about the discovery of this test block that had been covered with sand and vegetation. Working with the National Park Service, members of AGFA cleared the area to reveal the historic test block and supporting blocks. The bolts seen above are over one-inch in diameter. (Past image, courtesy of CMH; present image, courtesy of Geri Gray.)

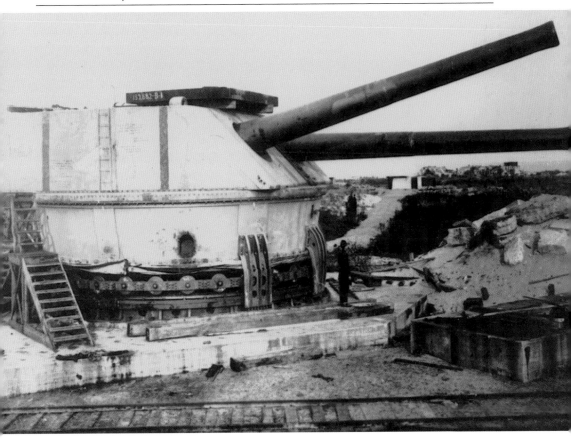

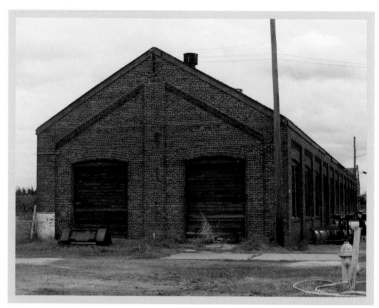

Several redbrick buildings were built to provide support to the entire proving ground. When the peninsula was renamed Fort Hancock in 1895 and the Coast Artillery assumed majority control of Sandy Hook from the Corps of Engineers, it shared the peninsula with the proving ground for some time, but the work was always considered top secret. As a result, the proving ground and Fort Hancock kept their distance from each other even though the proving ground relied on Fort Hancock for key support services and utilities. Some of the abandoned buildings still stand today but are off-limits to the public. (Past image, courtesy of GATE; present image, courtesy of Geri Gray.)

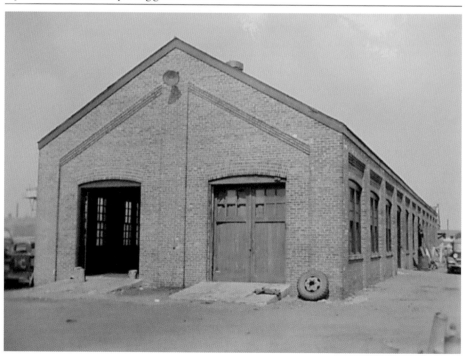

TESTING WEAPONS OF WAR

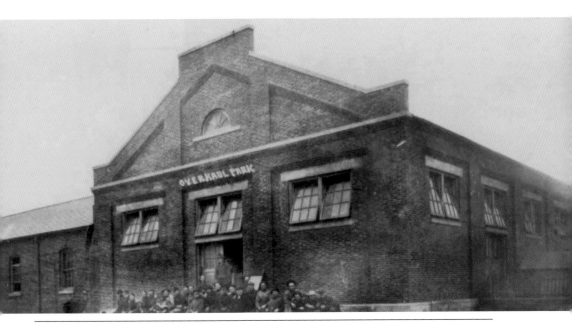

This building was affectionately named Overhaul Park and was one of many buildings that supported the efforts of the proving ground and, later, the 52nd Coast Artillery Regiment (Railway). Services provided here included locomotive and railway equipment and weapons maintenance, carpentry, welding, painting, construction, testing, metallurgy, and design. Most of these buildings are behind a chain-link fence and are no longer used, except in some cases for storage and specialized work by the National Park Service. (Past image, courtesy of Les Horner Collection; present image, author photograph.)

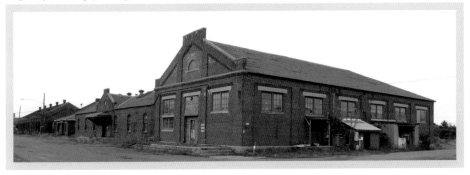

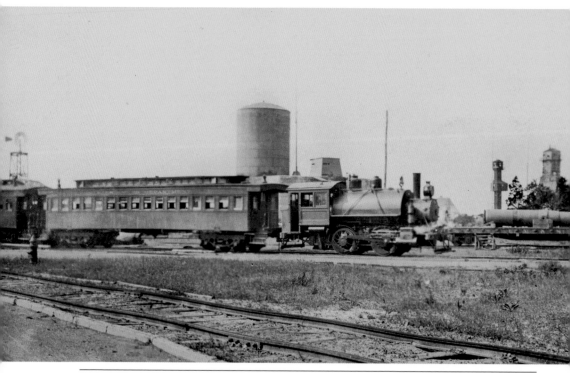

A narrow-gauge railroad was constructed in 1889 to bring equipment and guns from the docks to the proof battery. In 1893, a standard-gauge railroad was completed to the mainland and connected with commercial railroad lines. The trains (above) also moved ammunition and supplies to individual gun batteries. While the great majority of railroad tracks were removed, some of them are still in the ground near the redbrick buildings used by the proving ground or near the nine-gun battery and north parking. Most of the routes where train tracks once ran throughout Sandy Hook are now bicycle and walking paths. (Past image, courtesy of GATE; present image, author photograph.)

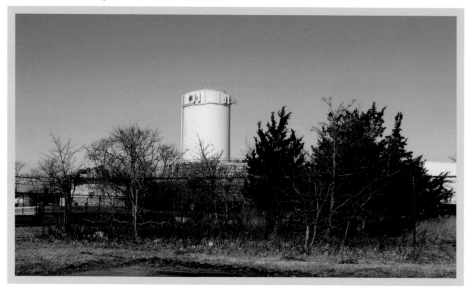

TESTING WEAPONS OF WAR

CHAPTER 3

ESTABLISHING ARMY TOWN

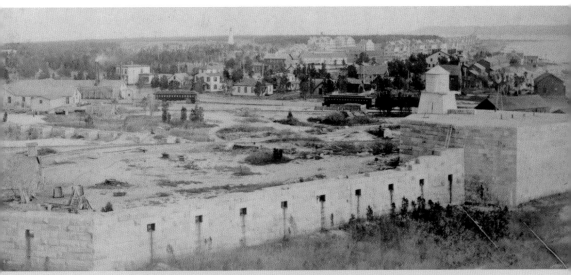

After the Civil War, enemies from abroad were developing ships that could attack the young country. New York City was considered a prime target, and so the Fort at Sandy Hook began to be constructed in 1859 but was never completed because new weaponry had made the masonry fort obsolete. This c. 1905 photograph, taken by Thomas Smedley, shows part of the masonry fort in the foreground. It was designed in the late 1840s, and the drawings have the signature of Capt. Robert E. Lee, who was an engineer officer with the US Army Corps of Engineers prior to the Civil War. In 1861, Lee resigned his commission and became the commander of the Army of Northern Virginia as part of the Confederate states. (Courtesy of GATE.)

A water tower sits on the last remaining part of a five-sided granite fort approved by Robert E. Lee in 1850. Construction was halted by Congress in 1870, pending a report from the secretary of war on fortifications. The granite blocks were removed to become seawalls to protect the shoreline. Today, the water tower is on Coast Guard property and can be seen through a barbed wire fence. (Past image, courtesy of CMH; present image, courtesy of Geri Gray.)

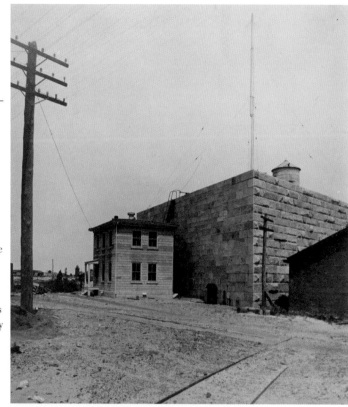

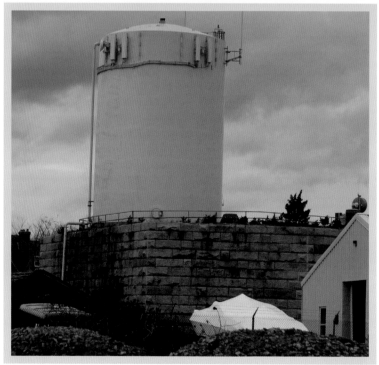

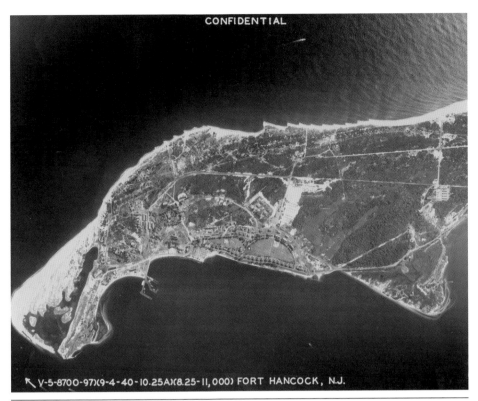

V-5-8700-97)(9-4-40-10.25A)(8.25-11,000) FORT HANCOCK, N.J.

Sandy Hook was the best location to build a fort to defend America from an enemy invasion. The above photograph, taken in 1940, was classified at the time. Defending New York City from an invasion by land, sea, or air was the primary objective of Fort Hancock, which worked in coordination with a system of forts throughout the area. All of Sandy Hook is managed by the National Park Service and US Coast Guard. (Past image, courtesy of GATE; present image, courtesy of Alamy Stock Images.)

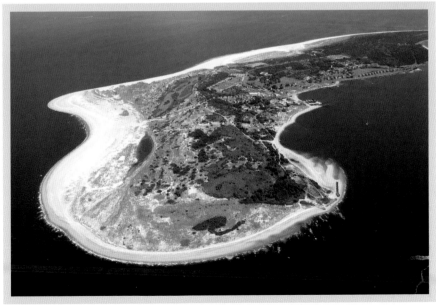

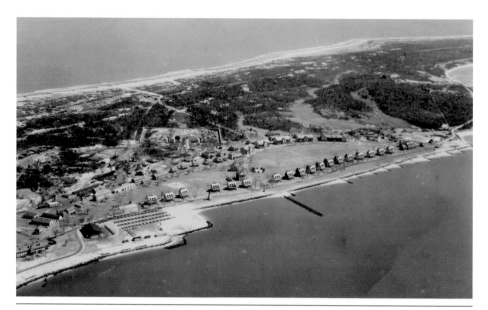

The Fortifications at Sandy Hook became Fort Hancock in 1895 and existed until 1974. At the height of World War II in 1943, there were about 5,500 combat soldiers and another 3,000 support soldiers, civilians, and military family members at the installation. By April 1944, the combat garrison dropped to just over 1,000 soldiers. By 1945, the post served as a reception center for military personnel returning from Europe. Above is a c. 1930 view looking north. Homes for married officers are on the left facing Sandy Hook Bay, while the barracks for enlisted men (and later women) are on the right side of the parade grounds, seen in the middle of both photographs.

Today, the National Park Service has developed a public leasing program for the rehabilitation of 36 historic Fort Hancock buildings. Some of the historic buildings have been leased by private entities to become residences, restaurants, and other businesses to improve the public's experience in the park. Some of the buildings are occupied by employees of the National Park Service, while larger buildings house a variety of nonprofit organizations. Today, all of Sandy Hook is listed in the National Register of Historic Places. (Past image, courtesy of GATE; present image, courtesy of USAHEC.)

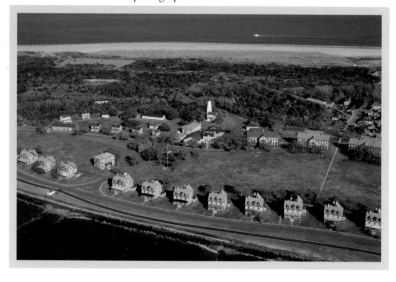

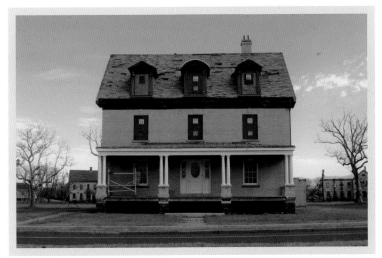

Many of the 32 buff-colored brick buildings of Fort Hancock were designed in the Colonial Revival style and built by 1899. The buildings included officers' quarters, barracks, bachelor officers' quarters, post headquarters, hospital, guardhouse, quartermaster storehouse, and bakery. The heavier, more costly buff-colored brick was chosen because it was less porous than traditional red brick. The commanding officer's home (building No. 12) was erected in 1899 and located along "Officers' Row" by Sandy Hook Bay. It was the largest of all the officers' houses. Today, the house can be identified by the canon in front of it. It is one of many homes that were damaged by Hurricane Sandy and are available to lease for rehabilitation and occupancy. (Past image, courtesy of GATE; present image, courtesy of Dreamstime.)

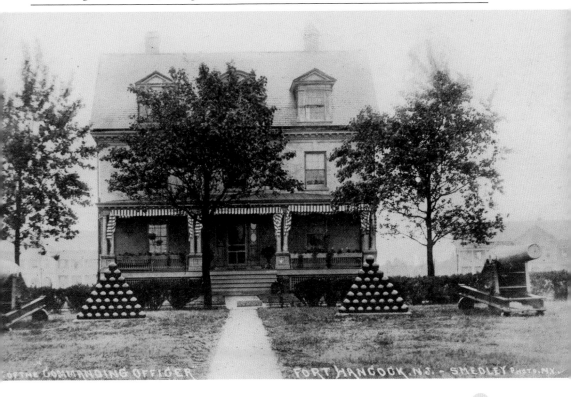

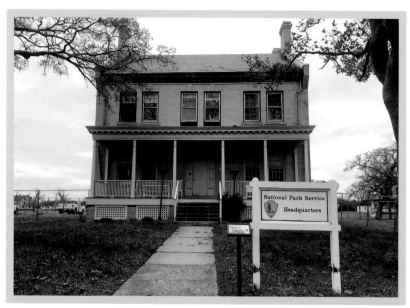

The headquarters for Fort Hancock (building No. 26) was constructed on Hudson Road in the late 1890s and faces south toward the parade ground. Behind the building is the post athletic field on the other side of Lawson Lane. In 1974, the last commanding officer of Fort Hancock officially deactivated and transferred the fort to the National Park Service. Today, the National Park Service oversees the use of many of the fort's buildings by more than a dozen different educational, scientific, educational, and environmental groups. Building No. 26 is now the site headquarters for the National Park Service. (Past image, courtesy of CMH; present image, courtesy of Geri Gray.)

The bachelor officers' quarters (building No. 27) was erected in 1898 at the north end of the parade ground next to the Fort Hancock headquarters on Hudson Road. Behind the building is the post athletic field on the other side of Lawson Lane. Officers at Fort Hancock held ranks from second lieutenant to brigadier general. (Past image, courtesy of the John Rhody collection; present image, courtesy of Geri Gray.)

One of the architectural landmarks of the post is a line of 18 homes known as Officers' Row, between Hartshorne Drive and Kessler Road. Each of the houses was built to house an officer and his family. Married officers very likely lived here in a yellow-brick home (seen above around the 1910s), which was built in the late 1800s and faced Sandy Hook Bay. Sadly, time and weather have affected the structural integrity of many of these historic homes, but some are being restored, and all but one is available for lease to qualified applicants. (Past image, courtesy of the National Archives; present image, courtesy of Geri Gray.)

The below 1971 photograph, taken shortly before Fort Hancock was closed, shows the continuation of Officers' Row on Hartshorne Drive. The closest house is building No. 6. Behind these houses is the athletic field. The National Park Service provides information for walking or cycling tours to visit many of the historic locations and structures to learn more about Fort Hancock, the proving ground, and the Sandy Hook Lighthouse. (Past image, courtesy of GATE; present image, courtesy of Geri Gray.)

ESTABLISHING ARMY TOWN

Across from Officers' Row and on the other side of the parade grounds are four barracks (buildings Nos. 22–25) like the one below, where many of the soldiers lived and slept. These included members of the Women's Army Corps, who were housed in building No. 25. Male soldiers, who called it the "WAC Palace," were denied entry. Today, barracks building No. 23 (above) and its detached mess hall (building No. 56) are being restored and converted to classrooms, storage, and other space for high school students who are part of the Naval Junior ROTC program of the Marine Academy of Science and Technology (MAST), a career academy in the Monmouth County Vocational School District. (Past image, courtesy of GATE; present image, courtesy of Geri Gray.)

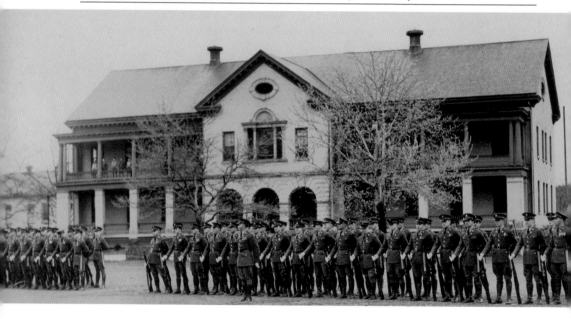

The soldier seated at center above on the steps of barracks No. 24 is none other than Tom Mix, a famous actor in silent movies. Before his acting career, he joined the US Army as a volunteer when the Spanish-American War began in 1898. He was promoted from private to first sergeant in relatively short order. However, he left (or deserted) Fort Hancock in 1902 without any explanation. Later, he was in Oklahoma working as a star in a rodeo. From there, he became a stunt man in early silent movies. He became one of the most famous movie stars of the early 20th century, acting in almost 300 movies over 26 years. (Past image, courtesy of GATE; present image, courtesy of Geri Gray.)

There was a lot of posing for the camera during the 1930s and 1940s, such as the soldiers at right were doing in front of the barracks. From December 1941 through the spring of 1945, soldiers living and working in "Army Town" were on alert. Armed soldiers would regularly patrol the beaches and roadways, while others stood guard 24 hours a day. All were issued ammunition and had to keep their weapons with them at all times. In 1940, Pres. Franklin D. Roosevelt mobilized the National Guard, and the draft was initiated. As a result, Fort Hancock gained more than 3,000 soldiers as the members of the 245th Coast Artillery Regiment (New York National Guard) arrived, and the 52nd Coast Artillery, 7th Coast Artillery, and support units were filled to wartime strength with draftees. In May 1941, President Roosevelt declared a state of national emergency, and all harbor defenses went on alert. By January 1943,

Fort Hancock reached more than 5,500 combat personnel with the arrival of the 265th Coast Artillery Regiment, which left for Alaska in January 1944. From January to April 1944, the combat garrison was reduced from about 5,500 men to about 1,000 with the departure of the remaining elements of the 7th, 52nd, and 265th Coast Artillery Regiments and the reduction of the 245th Regiment from four battalions to one. By 1945, Fort Hancock became a demobilization station for troops returning from Europe. Five years later, the harbor defenses of New York were deactivated, and all Coast Artillery troops departed Fort Hancock. (Past image, courtesy of GATE; present image, courtesy of Geri Gray.)

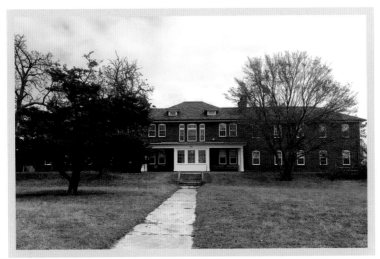

This T-shaped building (building No. 102) was erected in 1909 as the barracks for the soldiers associated with the proving ground. Later, after the proving ground left Sandy Hook, it became a barracks for personnel associated with the mine battery beginning in the 1920s. In 1941, wooden barracks were hastily constructed around the building as more and more soldiers came to Fort Hancock at the beginning of World War II. The last of these World War II wood barracks were demolished in mid-2020. (Past image, courtesy of GATE; present image, courtesy of Geri Gray.)

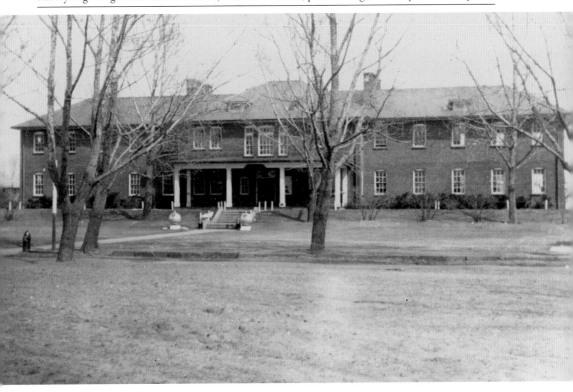

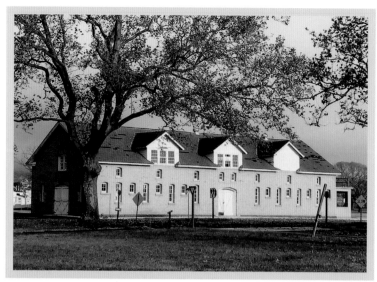

Built as a stable in 1899, building No. 36 was called the Mule Barn. Before automobiles, trucks, and tractors, everything was moved by horses and mules. The teamsters, or muleskinners, drove the teams of mules to pull equipment from one place to another. The corral, as it was also called, was close to one of the greenhouses on the post, possibly providing a convenient source for fertilizer. Besides using mules, soldiers regularly patrolled the beaches on horseback. In later years, the barn was converted to a barracks, and after that, a service club. Later, it became a mess hall. After Hurricane Sandy, it was used by the National Park Service as a woodworking shop. Negotiations are currently underway on a lease for it to become a restaurant. (Past image, courtesy of GATE; present image, courtesy of Geri Gray.)

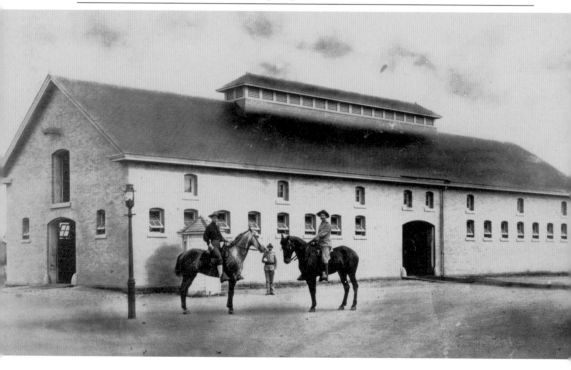

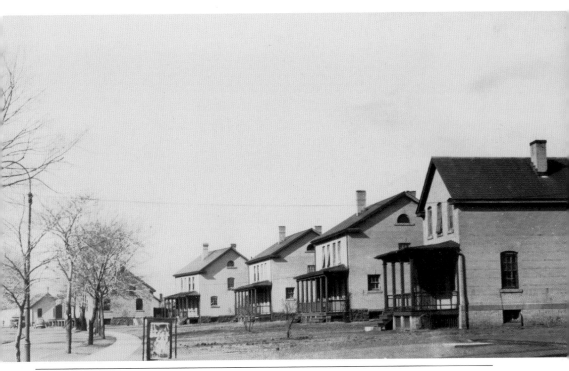

Along the athletic field on Kearney Road and close to the Sandy Hook Lighthouse is another row of houses (building Nos. 26, 30, 52, and 64) for the noncommissioned officers (NCOs) who had families. NCOs are generally sergeants of various grades. Each building was divided into two housing units. Today, most of these houses are used as living quarters for National Park Service staff and their families. Behind these houses are more quarters (building Nos. 26, 29, 66, 71, 72, and 73) on McNair and Mercer Roads, collectively known as "Sergeants' Row." Unmarried NCOs at Fort Hancock lived in special rooms in the enlisted men's barracks. (Past image, courtesy of GATE; present image, courtesy of Geri Gray.)

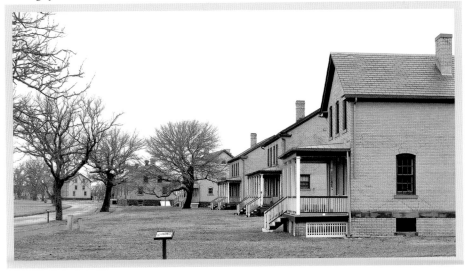

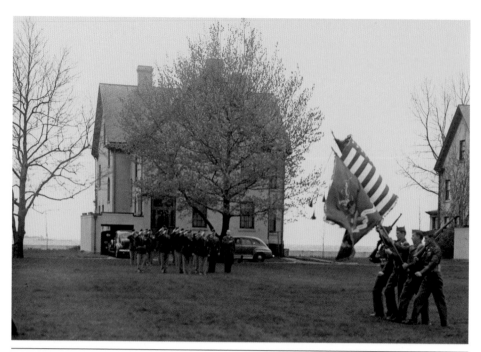

The photograph above from the parade grounds looks toward the back of one of the houses on Officer's Row. A handful of soldiers are heading south while parading with the colors. A lot of the married officers had automobiles, so a garage to the left of the house is visible. While damaged during Hurricane Sandy, many of these buildings are now available through the National Park Service historic leasing program for private citizens and groups to restore and operate under leases up to 60 years. (Past image, courtesy of GATE; present image, courtesy of Geri Gray.)

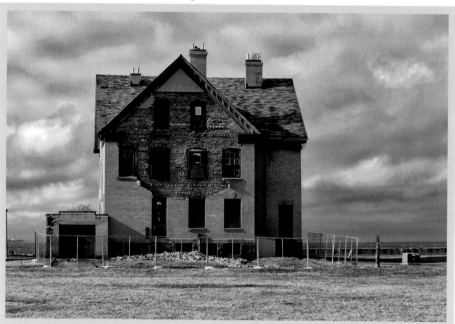

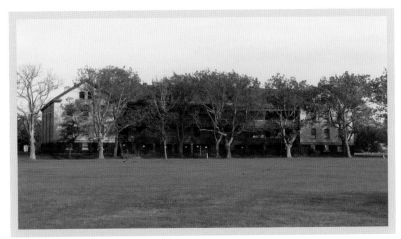

Building No. 74, between Magruder Road and the parade grounds, is a U-shaped building that houses the administrative offices of the James J. Howard Marine Sciences Laboratory, part of the Northeast Fisheries Science Center. Its primary mission is to conduct research in ecology, leading to a better understanding of both coastal and estuarine organisms and the effects of human activities on near-shore marine populations. Across the street from the U-shaped building erected in the late 1980s are 12 research laboratories, including a large, two-story 32,000-gallon research aquarium. This aquarium is housed in a sound-retardant room with a programmable lighting system that allows the simulation of daily and seasonal changes in light intensity for any time of the year and any place in the world. (Past image, courtesy of GATE; present image, courtesy of Geri Gray.)

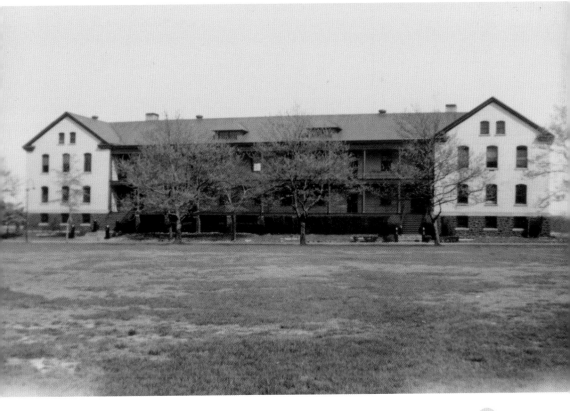

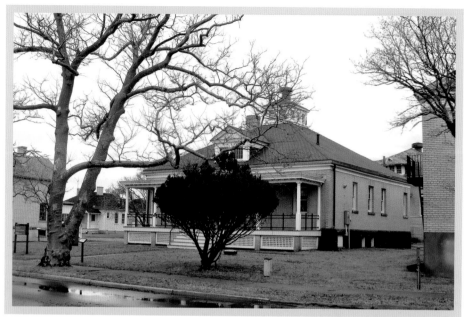

The post guardhouse and jail (building No. 28) was constructed in 1899. The guardhouse was where the installation commander managed the guard force. Prior to the advent of electrical intrusion detection systems and alarms, the Army used soldiers in large numbers to patrol and guard parts of Fort Hancock. This guard force normally numbered about 40 men every day, and the soldiers were drawn from all units. The jail is in the back of the building Today, it houses the Fort Hancock Museum, which reopened in 2018 after being closed due to damage by Hurricane Sandy. The jail cells are still present and contain displays about Fort Hancock. (Past image, courtesy of CMH; present image, courtesy of Geri Gray.)

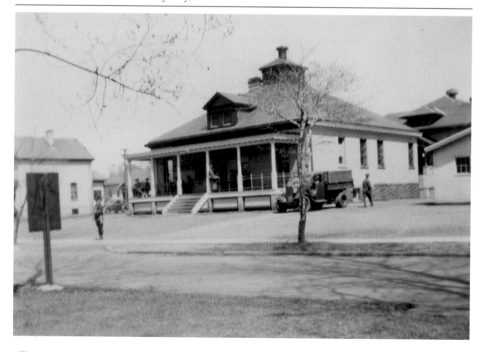

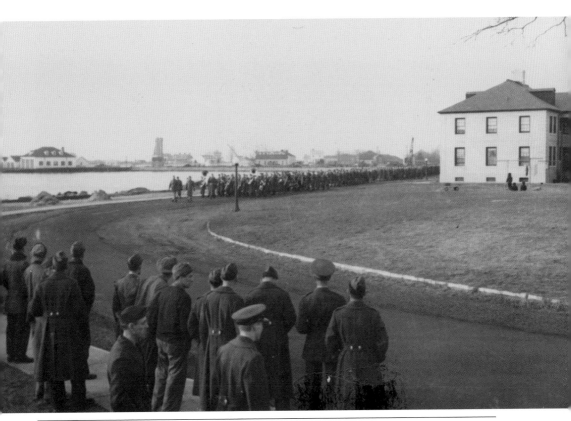

Another parade is progressing along a road by Sandy Hook Bay. Today, this location is behind a chain-link fence because it is on Coast Guard property. Coast Guard units have been stationed on this strategic plot of land since 1849, when the first lifesaving service station opened here. (Past image, courtesy of GATE; present image, courtesy of Geri Gray.)

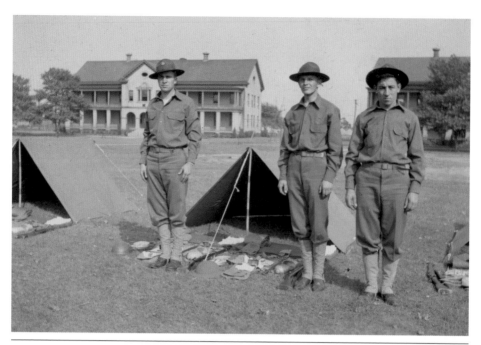

This is a one-person (maybe two-person) pup tent inspection on the parade grounds. The name "pup tent" is believed to be derived from the Civil War, when troops used the word "dog" in military slang, such as dog tags. For example, someone in the infantry nicknamed their tents "dog houses." From there, the name transformed into pup tents.

If a soldier at Fort Hancock could not find room in one of the cozy barracks, they slept in a large tent. Some tents were set up close to a soldier's assignment, such as a gun battery. (Past image, courtesy of GATE; present image, courtesy of Geri Gray.)

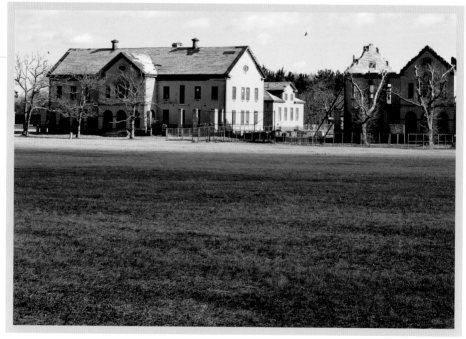

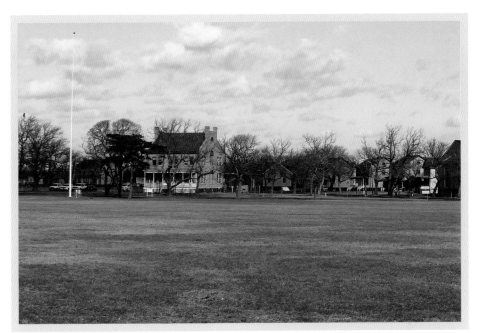

The parade ground was the largest field in Fort Hancock, where soldiers would march (as seen below during the 1940s), exercise, play sports, or conduct inspections of equipment. On the north end of the parade grounds below is a large American flag; the matching flagpole above is empty. Like many Army posts of the day, photographs were not always allowed to be taken, especially when the country was fighting a war. (Past image, courtesy of GATE; present image, author photograph.)

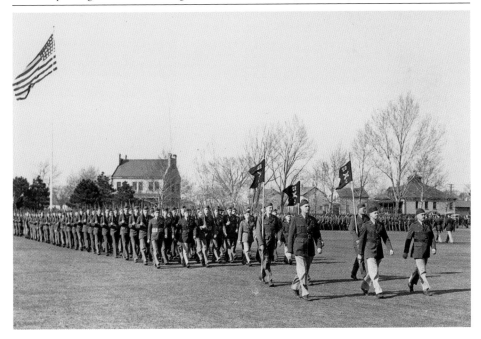

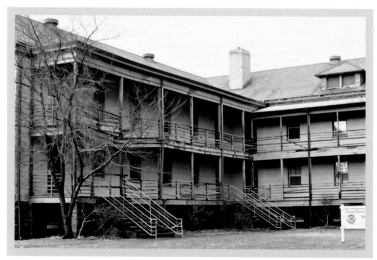

Building No. 74, seen below around 1940, when the 245th Coast Artillery Regiment of the New York Guard reported to Fort Hancock for federal service, was the only U-shaped building used as barracks for soldiers at Fort Hancock. Today, it is one of many buildings restored and then occupied by nonprofit organizations, such as the National Oceanic and Atmospheric Administration, or NOAA. (Past image, courtesy of GATE; present image, courtesy of Geri Gray.)

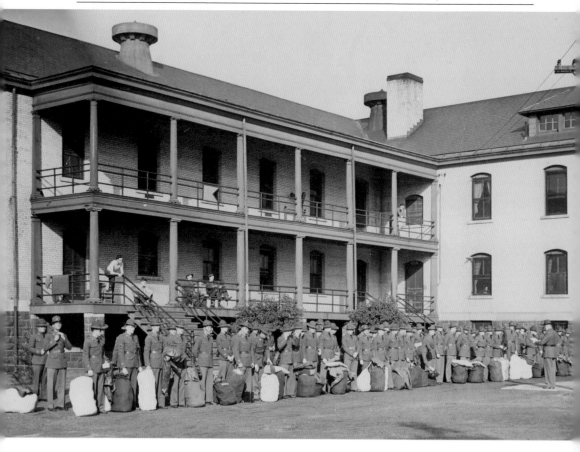

ESTABLISHING ARMY TOWN

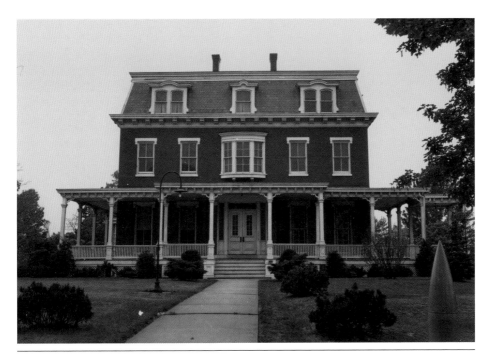

The Officers' Club (building No. 114) was built in 1879 as the officers' quarters of the Sandy Hook Proving Ground. The building was called the "Brick House" as early as 1898, a common name during the 1930s. In 1901, it was the officers' quarters and mess. When the entire proving ground was transferred to Aberdeen in 1919, the building became the Officer's Club at Fort Hancock. It is one of the oldest Army buildings at Sandy Hook. The Fort Hancock Officers' Wives Club used the Officer's Club during the 1960s for meetings and receptions. Military personnel used the building through 1974, the year when most of Fort Hancock was transferred to the National Park Service. The Officer's Club was occupied as a residence by park personnel from 1977 through 1981, when its use was discontinued due to poor conditions. Today, the building is unoccupied and is in lease negotiation to become an event space. (Past image, courtesy of GATE; present image, courtesy of Geri Gray.)

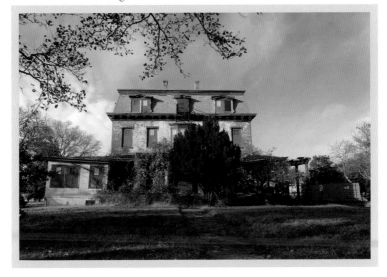

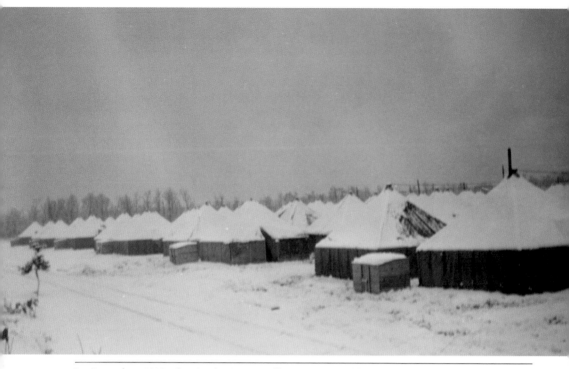

In September 1940, the 245th Coast Artillery Regiment was called into federal service, bringing more than 2,500 soldiers to Fort Hancock. At the same time, the 7th Coast Artillery and 52nd Coast Artillery were brought to wartime strength, adding another 1,500 soldiers. The brick barracks only housed about 1,500 soldiers. The remaining 2,500 soldiers were housed in large tents. The pyramidal tents shown above were in the tent city that was across from MAST and behind the NOAA laboratories. The photograph was taken during one of the coldest winters ever recorded, in early 1941. (Past image, courtesy of GATE; present image, courtesy of Geri Gray.)

ESTABLISHING ARMY TOWN

RECREATION AND ENTERTAINMENT

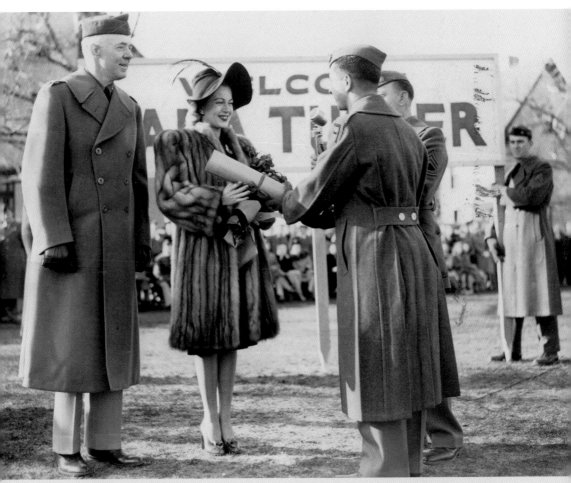

Entertaining the troops at home or abroad was always a priority to make certain morale was high. Fort Hancock was no exception, and finding celebrities to visit the soldiers was never a problem because New York City was close at hand. Actress Lana Turner (seen here) visited Fort Hancock on November 28, 1941—just days before Japan's attack on Pearl Harbor. She had been selected by the soldiers at the post as their favorite movie star. (Courtesy of GATE.)

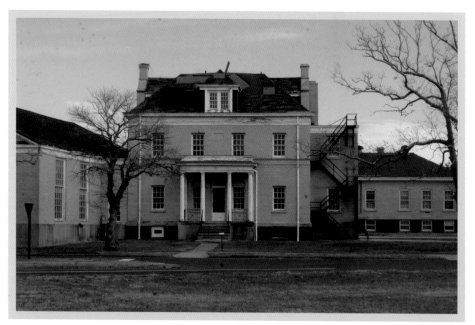

The building with columns seen below was the Young Men's Christian Association, erected in 1903. In 1940, a gymnasium (above on the left) was added next to the YMCA. The YMCA was founded in 1844 in London. The first YMCA in America was founded in Boston shortly thereafter. (Past image, courtesy of CMH; present image, courtesy of Geri Gray.)

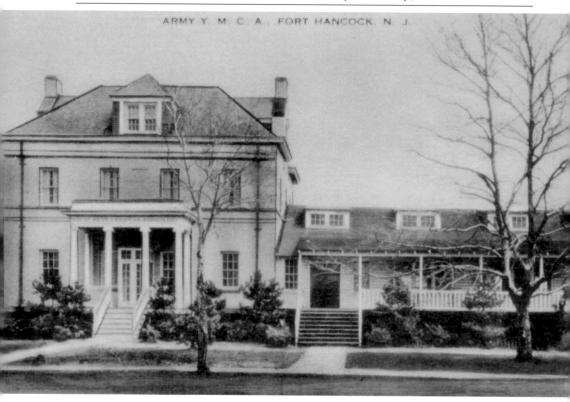

ARMY Y. M. C. A. FORT HANCOCK, N. J.

RECREATION AND ENTERTAINMENT

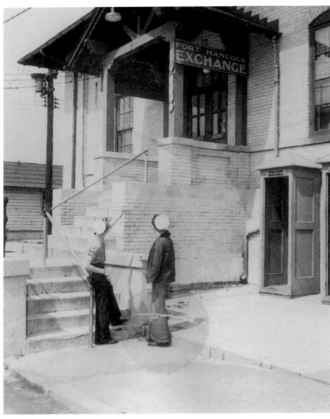

Building No. 70 was originally a gymnasium with a four-lane bowling alley in the basement. Eventually, a new gym was built next to the YMCA in 1941, and this building became the post exchange, where almost anything could be purchased, including food, toiletries, and souvenirs. (Past image, courtesy of Les Horner; present image, author photograph.)

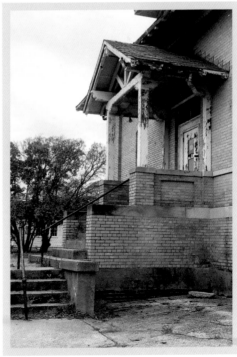

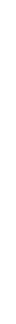

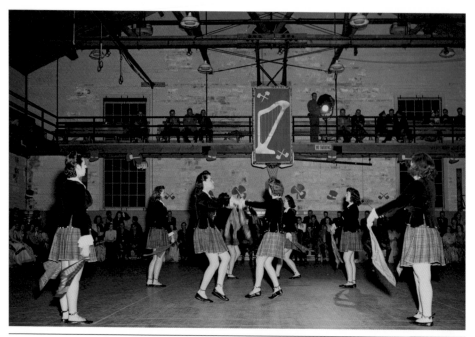

The above 1944 photograph shows a dance in the gymnasium celebrating St. Patrick's Day in March. The image below shows some of the damage done by Hurricane Sandy. Less than two months after the dance in 1944, the D-Day invasion began, with allied forces crossing the English Channel to land in Normandy. The success of the landing signaled the beginning of the end of the war in Europe. Unfortunately, the first attacks from V2 rockets caused further devastation to London, and then, the Battle of the Bulge was fought before the war in Europe ended. (Past image, courtesy of GATE; present image, author photograph.)

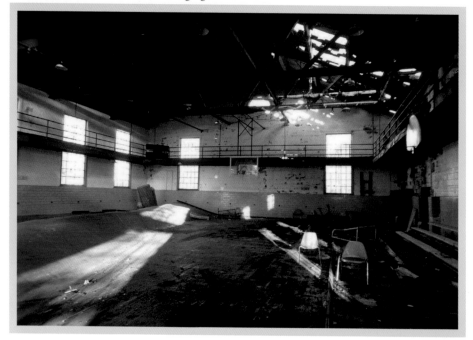

In the summer of 1941, prior to Japan's attack on Pearl Harbor, the Fort Hancock baseball team seen below was only focused on winning their game. Sports of all kinds were prevalent at Fort Hancock, especially on the parade grounds as well as the athletic field. The teams from various forts traveled to play each other. Sometimes, professional teams came to play, such as the New York Yankees in 1943. The backstop seen below behind the team still stands today. (Past image, courtesy of George Cerveny; present image, courtesy of Geri Gray.)

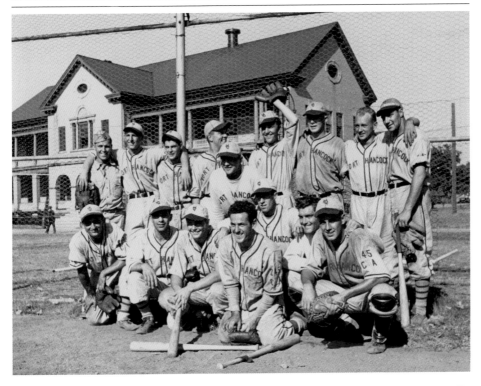

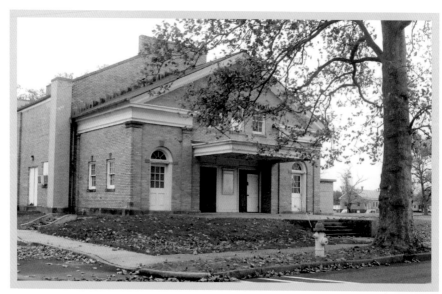

This was one of two theaters at Fort Hancock where soldiers and their families could be entertained by musical groups, movies, and celebrities. Some of the most popular films during the 1940s were war movies, such as *Casablanca*, *A Yank in the R.A.F.*, and *Thirty Seconds over Tokyo*. (Past image, courtesy of CMH; present image, courtesy of Geri Gray.)

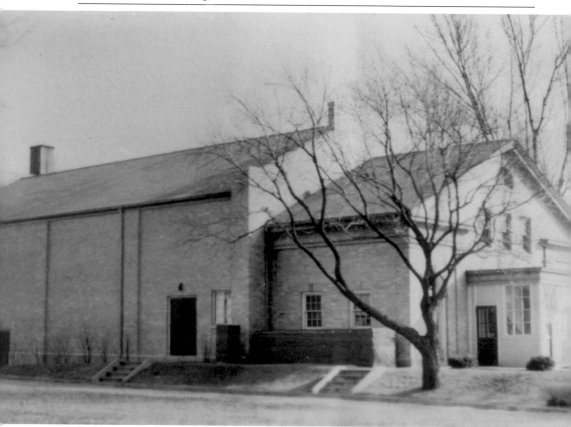

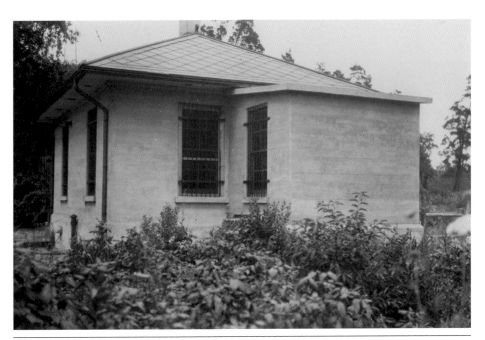

This is where the Fort Hancock radio station broadcasted popular songs and made announcements for the soldiers by the Special Services Division of the Army (later to become Armed Forces Radio). Some of the best-known tunes during the war years were "Somewhere Over the Rainbow," "White Christmas," and "We'll Meet Again." Popular artists of the era included Frank Sinatra, Ella Fitzgerald, and Glenn Miller. (Past image, courtesy of GATE; present image, courtesy of Geri Gray.)

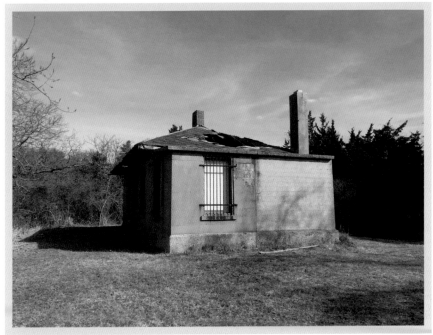

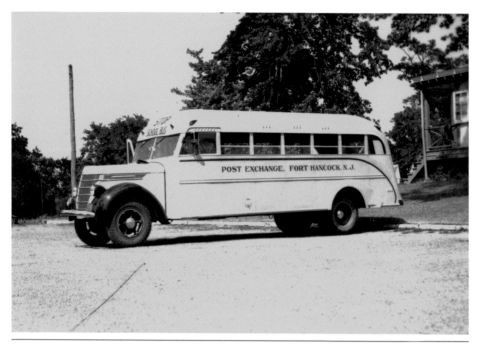

The post exchange was always a popular destination for soldiers and civilians who worked and lived at Fort Hancock, and so buses, seen above, stopped at barracks to pick up passengers. Today, there are still two bus stops on Sandy Hook. One of them, pictured below, is behind Officer's Row, but its roof is no longer present. The other bus stop is in front of the T-shaped building near the chain-link fence separating the national park from Coast Guard property. (Past image, courtesy of CMH; present image, courtesy of Geri Gray.)

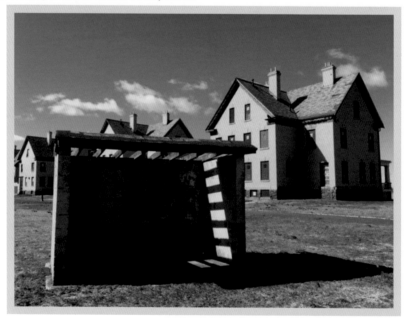

PROVIDING ESSENTIAL SERVICES

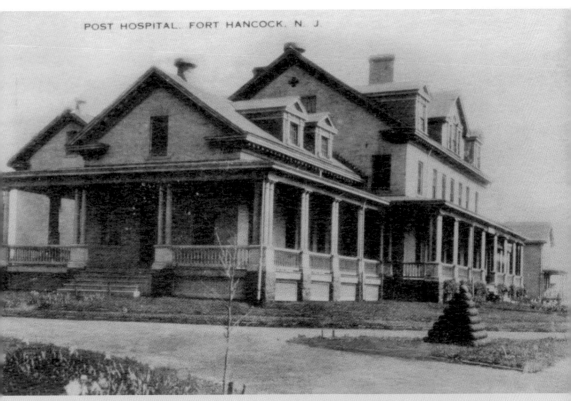

POST HOSPITAL. FORT HANCOCK, N. J.

This fully staffed 50-bed hospital was where soldiers and their families would go for a checkup, medical emergency, sickness, or physical therapy. The hospital, which had been built in 1898, burned to the ground in 1985, so nothing remains today. The building once used as a morgue, which stood next to the hospital, became the Army recruitment office in the 1960s and oddly remains as a public restroom today. (Courtesy of National Library of Medicine.)

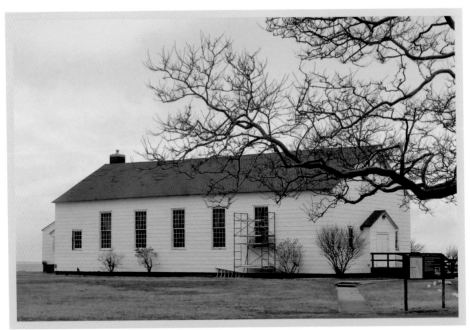

The Sandy Hook Chapel, built in 1941, was one of several places of worship at Fort Hancock. Today, the historic chapel (sans steeple) has been fully restored and may be used for weddings, family gatherings, memorials, meetings, and other special events. With a beautiful view of Sandy Hook Bay, the chapel is next to the dock used by the ferry service, which brings people from New York City and Atlantic Highlands. (Past image, courtesy of GATE; present image, courtesy of Geri Gray.)

PROVIDING ESSENTIAL SERVICES

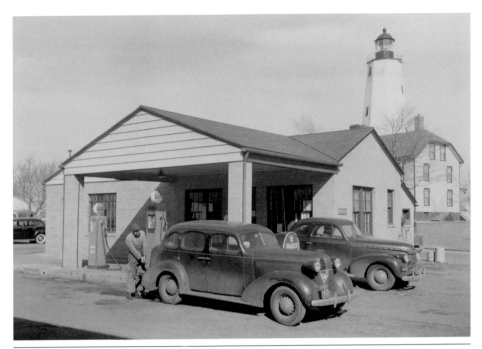

There were a lot of privately owned automobiles on Sandy Hook in the old days, and so there were a lot of tanks to fill with gasoline. The filling station (building No. 60) was erected in 1936 next to the Sandy Hook Lighthouse and was equipped with gasoline pumps and a garage to repair vehicles. A new car in the 1940s cost about $800. Gasoline averaged about 20¢ per gallon. On average, most cars got about 15 to 20 miles per gallon. (Past image, courtesy of CMH; present image, courtesy of Geri Gray.)

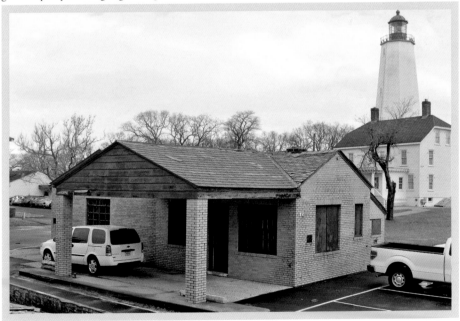

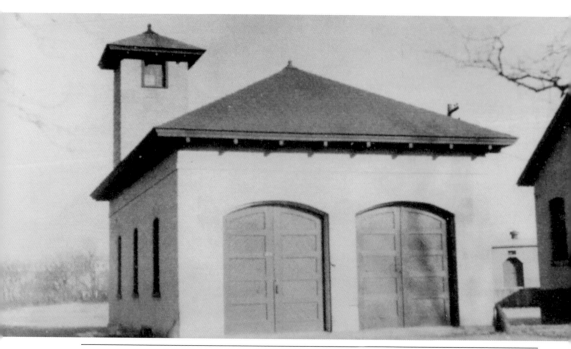

The firehouse, located next to the bakery, was built in 1905 and used by the Army until 1974. Today, the Sandy Hook Fire Department occupies the structure. The department is a National Park Service organization, and receives mutual-aid support from Highlands Fire Department. (Past image, courtesy of GATE; present image, courtesy of Geri Gray.)

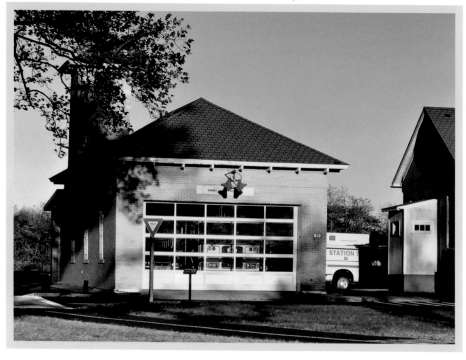

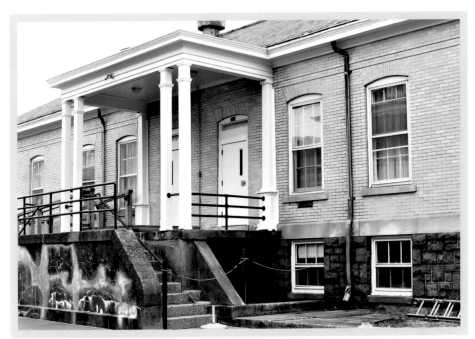

The post exchange (building No. 53) was and still is a type of retail store found on US military installations worldwide. Originally, they were like trading posts, but now they resemble department stores. Soldiers at Fort Hancock could sit at a snack bar there and eat a sandwich and drink a soda. It was conveniently located near the center of the post. Today, the original building is being leased long-term as a snack bar for tourists and those who work on Sandy Hook. (Past image, courtesy of GATE; present image, courtesy of Geri Gray.)

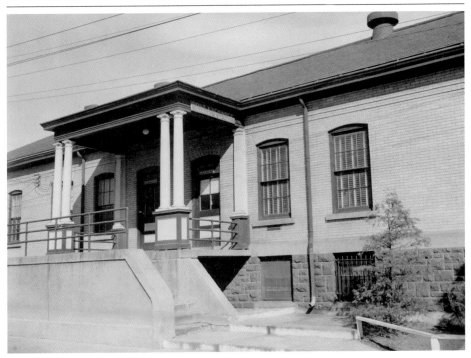

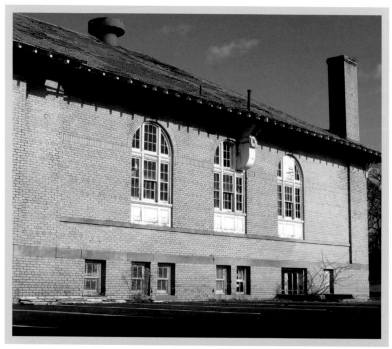

These cars below are parked next to the first post exchange (building No. 70) in 1909, where a bowling alley was in the basement. These cars all have 1942 license plates, helping to date the image. (Past image, courtesy of USAHEC; present image, courtesy of Geri Gray.)

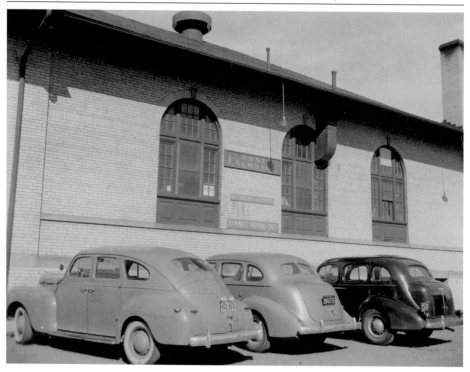

PROVIDING ESSENTIAL SERVICES

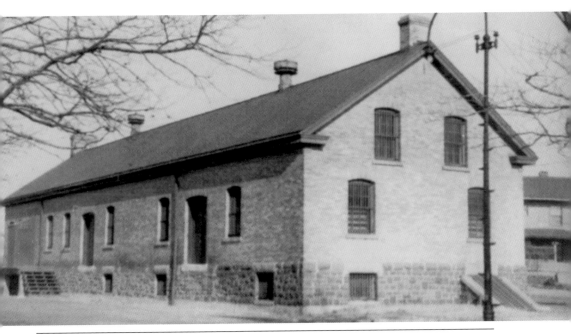

Fort Hancock's commissary was like a grocery store where soldiers and their families could purchase food to prepare their own meals and where the mess sergeants for the artillery batteries and ordnance, quartermaster, and other companies would requisition food to feed their troops. For most citizens at the time, food rationing was common during World War II. Many grocery items could be purchased with ration coupons. Many retailers welcomed rationing because they were already experiencing shortages due to rumors and panic. (Past image, courtesy of GATE; present image, courtesy of Geri Gray.)

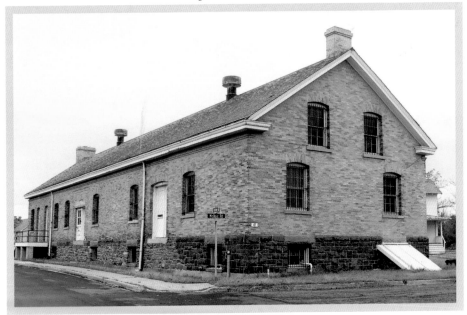

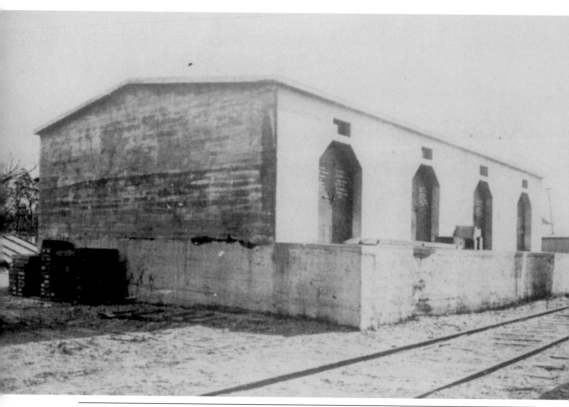

The only building left standing that was built during World War I is this one for storing paint and chemicals. (Past image, courtesy of National Park Service; present image, courtesy of Geri Gray.)

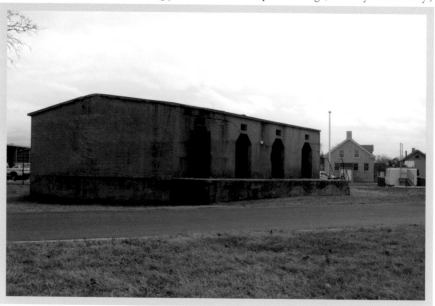

CHAPTER 6

SCANNING
THE HORIZON

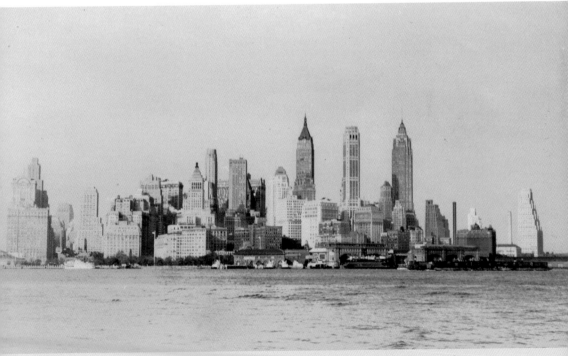

Defending New York City from an invasion by land, sea, or air was the primary objective of Fort Hancock, which worked in coordination with a system of forts surrounding the area. This image was captured around 1940. (Courtesy of Alamy Stock Images.)

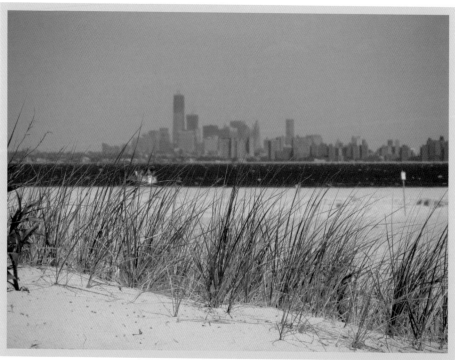

In the early part of the 20th century, enemy ships were of major concern, and so guns were developed to deter or destroy them. As technology moved forward, airplanes became more threatening and so anti-aircraft guns, such as this one seen on a beach on Sandy Hook during the 1930s, were installed along some of the beaches at Fort Hancock. The present-day photograph shows where one of the anti-aircraft guns was located, with New York City clearly seen in the background. (Past image, courtesy of CMH; present image, courtesy of Karen Oliver.)

The camp for the Civilian Conservation Corps (CCC), seen above around 1936, was located where the public campground is today. The CCC was a public work relief program from 1933 to 1942 for unemployed, unmarried men ages 18–28. The areas where the camps were established received many benefits. While the camps were in session, locals were hired as "local experienced men" who helped train the CCC enrollees. Much of the supplies and food for the camps were purchased locally, which further stimulated the economy. After the CCC was disbanded, the state parks and forests in New Jersey grew in size and number. (Past image, courtesy of GATE; present image, courtesy of Molly Hurford.)

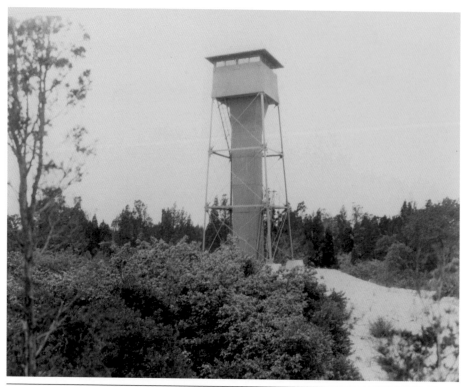

Dozens of fire control towers were located throughout Sandy Hook and down the Jersey Shore about 10 miles. They usually worked in pairs to determine directions that would be sent to plotting rooms, which would determine the locations of incoming ships for the soldiers firing the guns. A concrete stub once used as the base of a fire control tower inside the mortar battery is shown below. Many of the early photographs from a higher vantage point were either taken from the observation balloon or one of the dozens of fire control towers. (Past image, courtesy of GATE; present image, author photograph.)

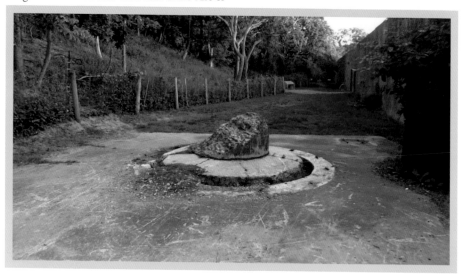

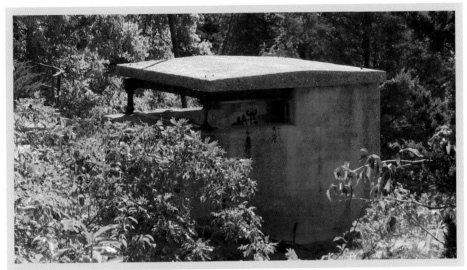

Other types of towers associated with gun batteries were used along with coincidence range finders, which would position an enemy target without needing data from another station. There seem to be only two of these range-finding structures left on Sandy Hook. One is along the shore of Sandy Hook Bay, but within the secured property of the Coast Guard. The one seen here is now surrounded by vines and bushes, off the beaten path. (Past image, courtesy of GATE; present image, author photograph.)

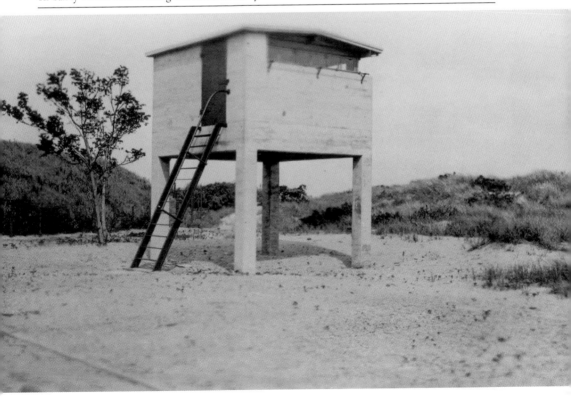

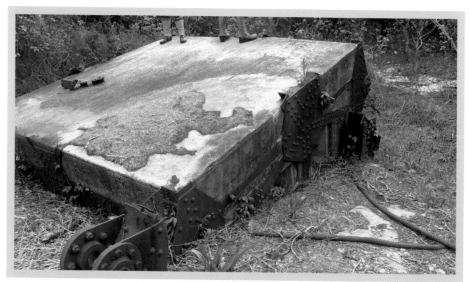

The so-called "disappearing searchlight" was quite the big deal during the 1920s because any lights seen by an enemy could be disabled in advance of an attack. This searchlight would tilt into a horizontal position, so it was hidden until needed. There were two such lights at Fort Hancock, and their counterweights and remaining foundations are along the south dune trail. (Past image, courtesy of CMH; present image, author photograph.)

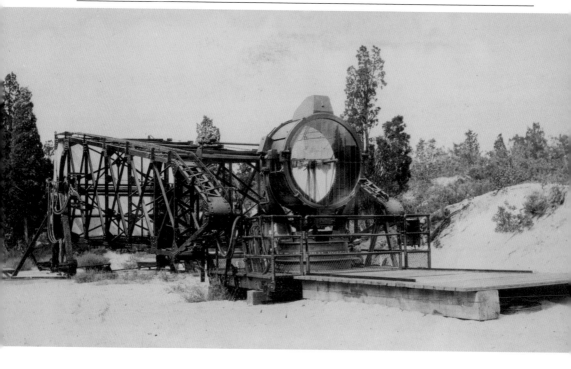

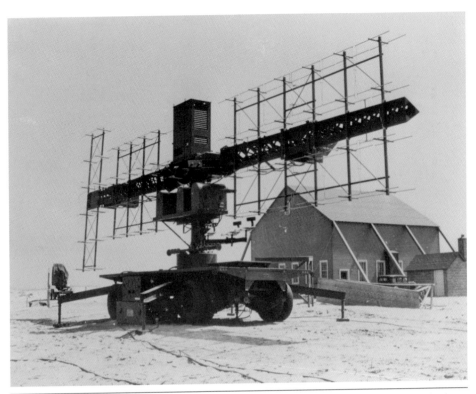

Early radar was first tested at nearby Fort Monmouth, and later at Sandy Hook for more privacy. Many of the secure positions were close to the beaches, but eventually, after all the equipment was removed after testing was completed, the concrete pedestals (below) were the only things left. Some were eventually covered with sand and disappeared. (Past image, courtesy of GATE; present image, author photograph.)

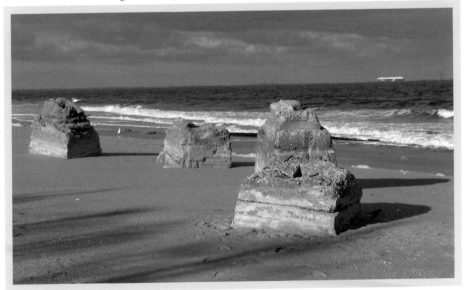

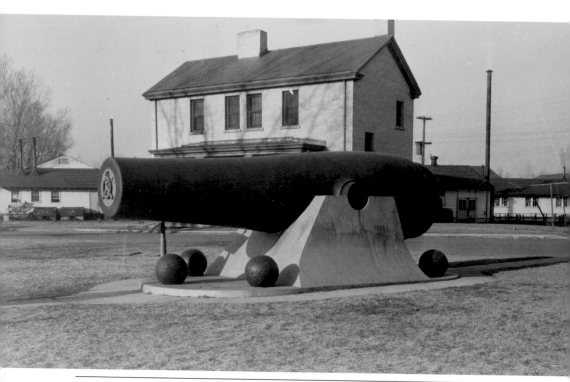

The photograph above was taken in the 1930s by Thomas Smedley, who had unprecedented access to the post at the time. The 20-inch Rodman gun seen in both photographs was a heavy Civil War–era gun intended to be mounted in seacoast fortifications. Only two such guns were made; one is at Fort Hancock, and the other is in a New York City park just outside Fort Hamilton. The guns differed from all previous artillery because they were hollow cast, a new technology resulting in guns that were much stronger than their predecessors. (Courtesy of GATE; present image, courtesy of Geri Gray.)

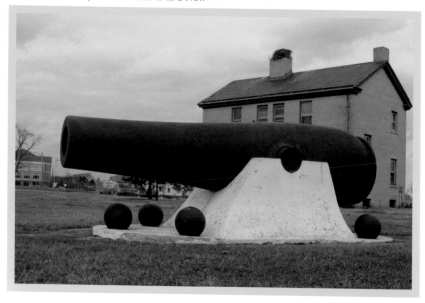

FIRING WEAPONS

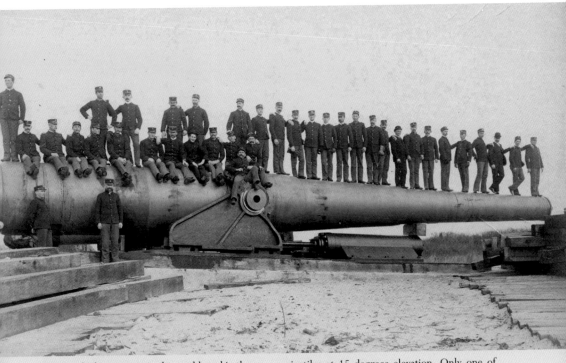

This was the biggest gun in the world, and in those days, big was always better. Weighing 284,500 pounds and about 50 feet in length, this M1895 16-inch gun has nearly two dozen men standing on it, with room for more. Completed in 1903, it had a firing range of 12 miles using 16-inch diameter projectiles at 15 degrees elevation. Only one of these guns was made and ultimately installed at Battery Newton in the Panama Canal Zone in 1917 and scrapped in late 1943. (Courtesy of GATE.)

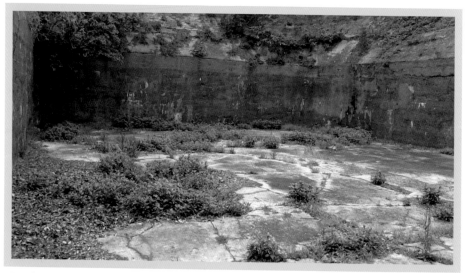

The Sandy Hook Mortar Battery, built between 1890 and 1894, was one of the first two concrete gun batteries built on Sandy Hook. Its M1886 cast-iron mortars fired in a high arc, with shells designed to come crashing down through the decks of enemy ships. The mortar battery has four mortar pits connected by a tunnel system where the shells and ammunition were stored and where the men who fired the big guns could be housed. By the 1920s, the M1886 mortars were obsolete, and they were removed. (Past image, courtesy of GATE; present image, author photograph.)

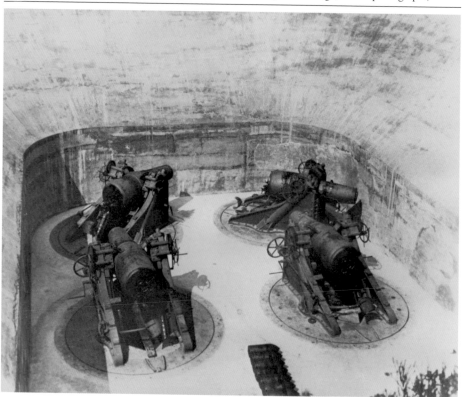

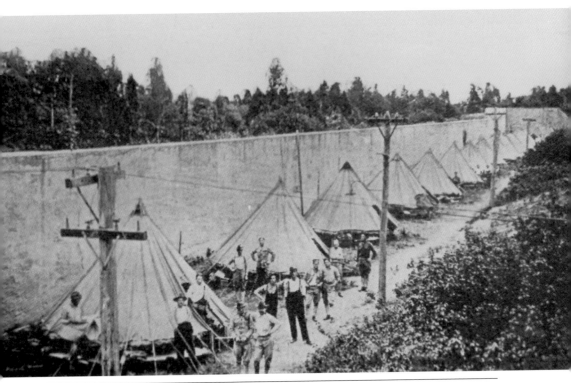

Every gun battery had troops assigned to it, who would sleep nearby and rotate in shifts so that there were always soldiers ready for action. Within the outside perimeter of the mortar battery were small windows where barrels of machine guns poked through. All gun batteries were protected by Army personnel stationed at nearby locations during wartime. (Past image, courtesy of GATE; present image, author photograph.)

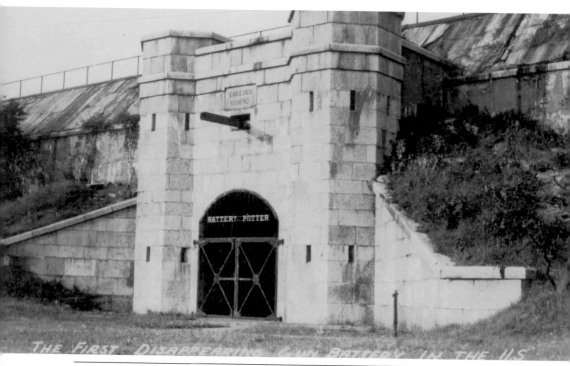

Battery Potter, constructed by 1890 and in operation until 1906, looks like a castle on a hill. Inside the walls was the first "disappearing" gun battery in America. The gun was out of sight when not used but could rise from a hidden position and then fall back to be reloaded and fired again. Originally called Lift-gun Battery No. 1, it was the first and only disappearing gun battery powered by a steam hydraulic lift system, but it was obsolete by the time it was built because firing it took over two minutes. The guns were removed in 1906. (Past image, courtesy of GATE; present image, courtesy of Geri Gray.)

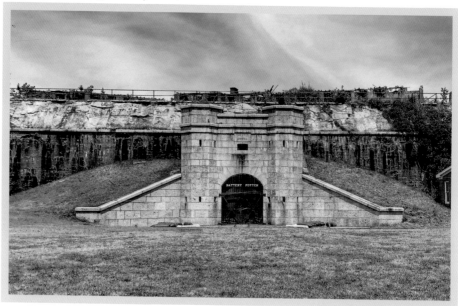

FIRING WEAPONS

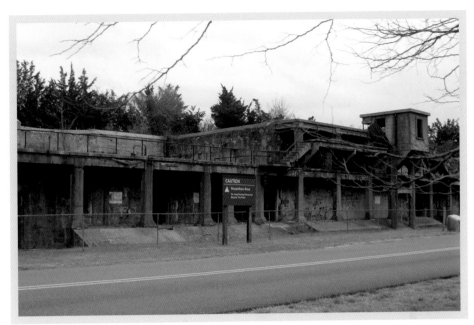

Battery Granger (operational from 1897 to 1942), one of the oldest gun batteries on Sandy Hook, was a reinforced concrete coastal gun battery with two M1888 10-inch seacoast guns on disappearing carriages. After it became obsolete in the early 1930s, Battery Granger was utilized for training and exercises until the guns were worn out in 1941 and scrapped in 1942. Many of the historic gun batteries are mostly ruins and are unsafe, so they should not be climbed upon. (Past image, courtesy of GATE; present image, courtesy of Geri Gray.)

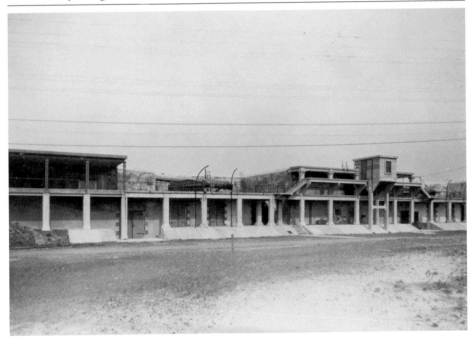

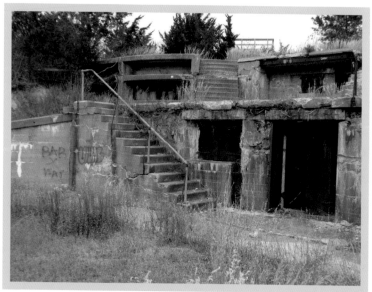

Old Battery Peck can be seen while walking on a dirt path toward the public observation tower at the north end of Sandy Hook. This was a small, two-gun battery completed in 1903 and named after Lt. Fremont Peck, who was killed while a gun being tested in 1895 at the Proof Battery exploded. The battery had two M1900 six-inch guns mounted on the upper level. In 1943, these guns were moved to Battery Gunnison, creating New Battery Peck. The old battery was modified to become an anti-torpedo boat battery, renamed Battery No. 8, with two 90mm guns that remained in place until shortly after 1946. (Past image, courtesy of CMH; present image, courtesy of Geri Gray.)

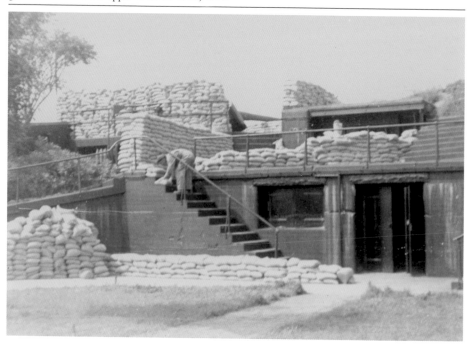

The Nine-Gun Battery began as a three-gun battery called Battery Halleck, with construction completed in 1899. Eventually, two guns were added on the north end to become Battery Alexander. The next two guns to the south were Battery Bloomfield, and then two more were added south of Battery Bloomfield in 1904 to create Battery Richardson. (Past image, courtesy of CMH; present image, courtesy of Alamy Stock Images.)

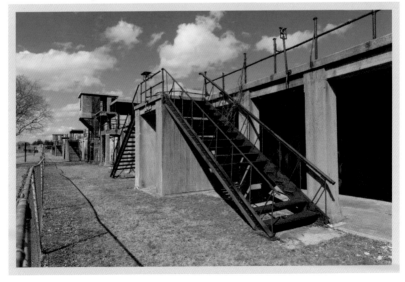

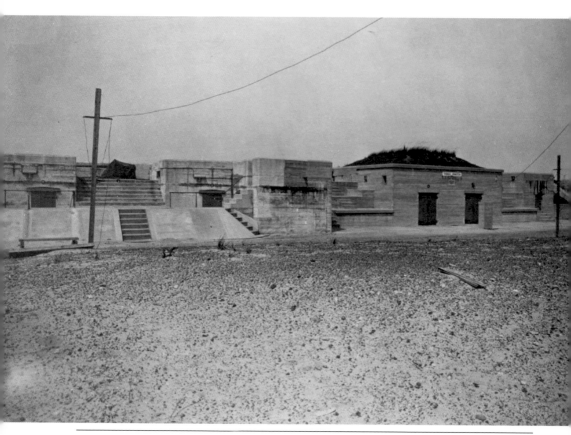

Battery Urmston (above), along with Batteries Morris, Engle, Peck, and Gunnison, contained rapid-fire three-, five-, and six-inch guns that were assigned to protect the extensive minefield in the bays and harbors. Today, Battery Urmson sits next to a barbed-wire fence, with Coast Guard property on the other side. (Past image, courtesy of GATE; present image, author photograph.)

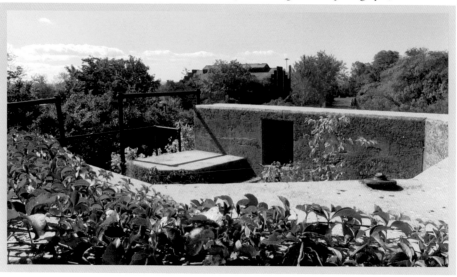

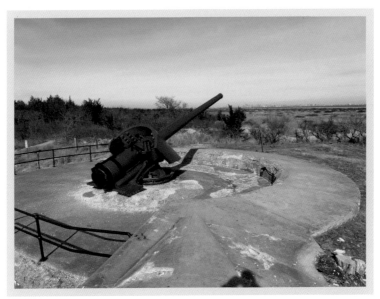

Battery Gunnison was built in 1904 as a rapid-fire twin six-inch disappearing gun battery. The two M1903 six-inch guns, mounted on counterweight disappearing carriages, were medium caliber weapons that could be fired rapidly at faster-moving enemy vessels, such as patrol boats, destroyers, or minesweepers. In 1943, this battery was extensively modified both internally and externally for two M1900 six-inch pedestal-mounted guns with two shell hoists and a modern plotting room. The guns were moved from old Battery Peck to Battery Gunnison, gaining a better field of fire and creating New Battery Peck. Today, the National Park Service and the Army Ground Forces Association are working to restore Battery Gunnison/New Battery Peck. (Past image, courtesy of GATE; present image, courtesy of Geri Gray.)

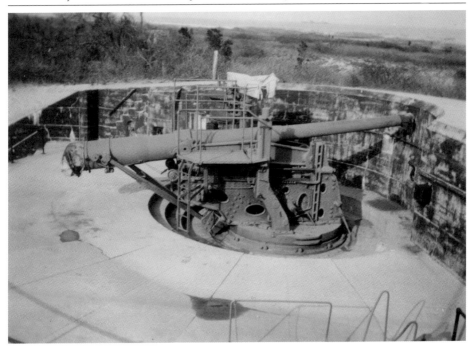

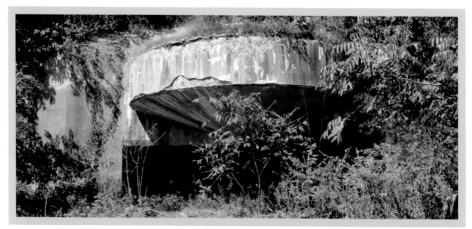

Battery Kingman and Battery Mills were constructed by 1919 next to each other on the bay side, with M1895 12-inch guns mounted on M1917 barbette carriages. They shot 975-pound armor-piercing projectiles 17-plus miles, had a 360-degree range of fire, and were Fort Hancock's primary defense against naval attack during World War II. In the beginning, these guns were uncovered and out in the open. Eventually, they were covered with concrete. In addition, the casements were covered with soil and vegetation to further hide their location, making them impervious to air attack and all but direct hits from battleship guns. (Past image, courtesy of CMH; present image, author photograph.)

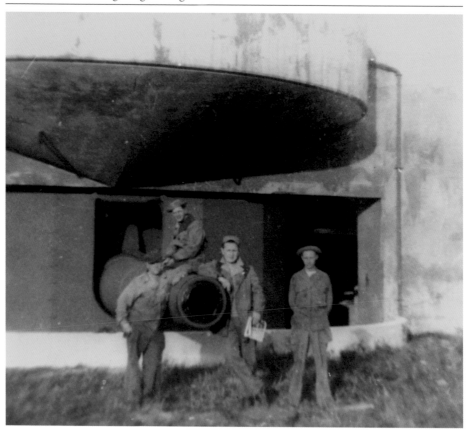

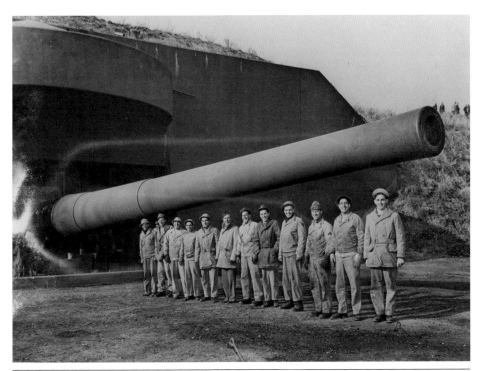

By 1941, the Army added the Navesink Military Reservation, also known as the Fort Hancock Annex, in today's Hartshorne Woods Park in Highlands. Beginning in late 1941, two batteries were constructed: Battery Lewis, a 16-inch casemated gun battery, and Battery 219, a 6-inch long-range barbet gun battery. Shown above is the crew at Battery Lewis that tested the guns in late 1943. As perhaps expected, none of the guns were fired toward any enemies approaching from the east. Today, a Navy Mk-VII 16-inch gun, slightly smaller than the original Navy 16-inch Mk-II gun originally mounted, was moved to the park as a tribute to those soldiers located here. Monmouth County maintains the location as both a public park and a museum. (Past image, courtesy of Monmouth County Park System; present image, author photograph.)

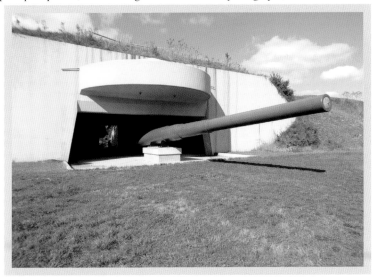

Battery Arrowsmith, with its three M1888 eight-inch disappearing guns, was completed in 1909. This bay side gun battery could protect Sandy Hook Bay, which was beyond the other disappearing guns' field of fire. This was the only seacoast battery built to fire "behind" the primary installation (Fort Hancock) and cover a bay area. The battery was disarmed around 1928, after the completion of Batteries Kingman and Mills. From this location, there is a clear view of Officer's Row, as well as Highlands and Atlantic Highlands. Just like all other gun batteries, railroad tracks once existed at this location. (Past image, courtesy of CMH; present image, author photograph.)

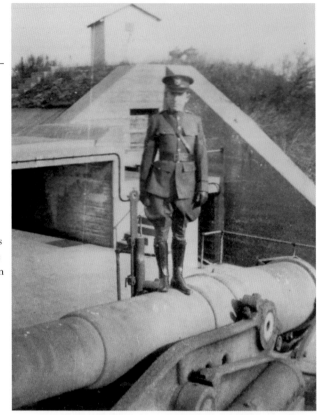

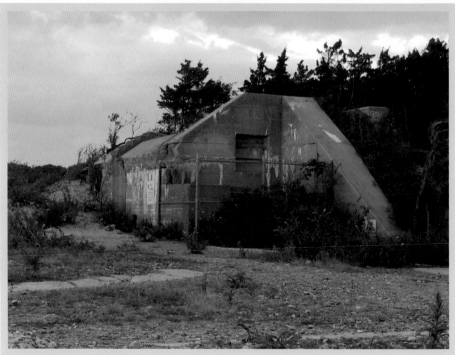

MODERN WARFARE

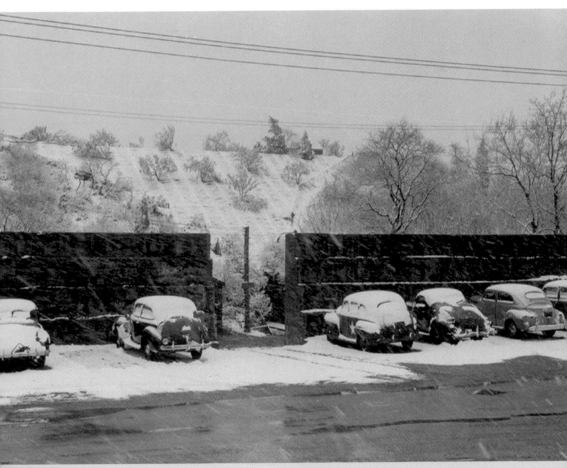

During World War II, Fort Hancock was the location of the headquarters of the harbor defenses of New York. From a secure tunnel system in the former mortar battery, all defenses of lower New York Harbor were coordinated, including the military activities of Forts Hancock, Tilden, Totten, Hamilton, and Wadsworth. This photograph was taken in early 1944. (Courtesy of GATE.)

The oldest gun battery at Fort Hancock, the Mortar Battery, included an extensive tunnel system initially meant for storage of supplies and ammunition. During World War II, however, the tunnels were converted into a top-secret command center called the Harbor Defense Command Post for the defense of the New York City area. The communications room is shown below in April 1941, while the same room today is shown above. (Past image, courtesy of CMH; present image, author photograph.)

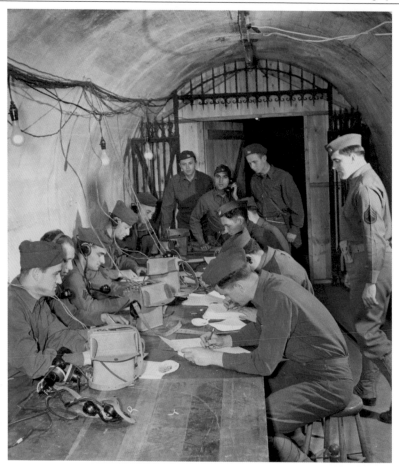

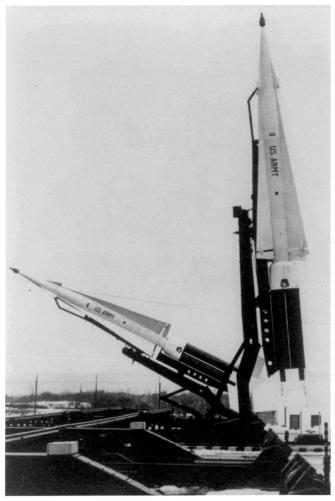

During the Cold War, Fort Hancock's mission changed as the new threat to the United States was the Soviet "Bear" bomber (TU-95), flown continually just outside of US air space. As a result, Nike site NY-56 was built as one of many sites throughout the United States to deter the Soviets from attacking. The missile launch area and its associated radar site were closed in 1974 when Fort Hancock was closed and turned over to the National Park Service. At one time, there were 24 Nike Hercules missiles that could carry a 20-kiloton nuclear warhead. (Past image, courtesy of Nike Historical Society; present image, author photograph.)

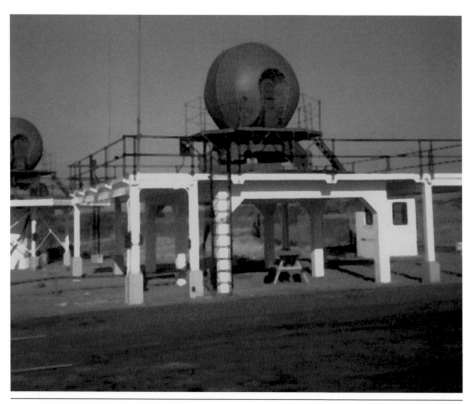

The Nike missile radar (shown above in 1973 and below today) would have helped guide the Nike missiles toward an enemy target, such as a Soviet bomber, and helped the Air Force track it. Radar was first tested and developed at Fort Monmouth, but later moved to Fishing Beach on Sandy Hook. Here, the Signal Corps tested and developed the SCR-268 air search radar unit, which was used by the Army during World War II. (Past image, courtesy of Nike Historical Society; present image, author photograph.)

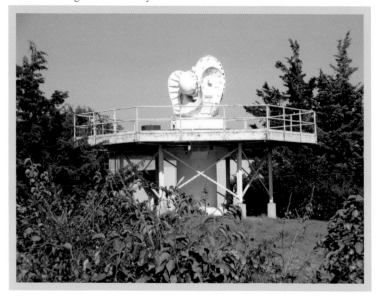

CHAPTER 9

CIVILIANS, VISITORS, AND TOURISTS

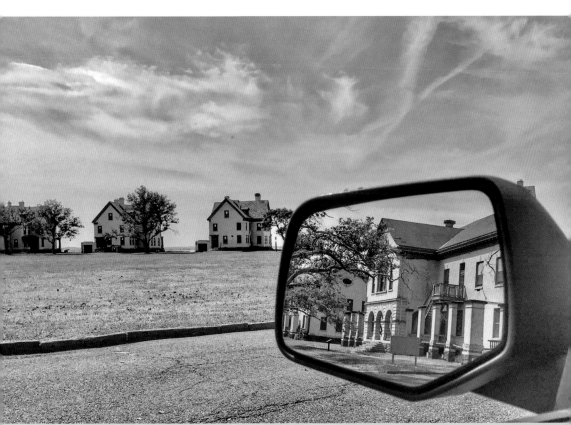

Today, tourists freely drive through history as they explore the past behind them. The history of Sandy Hook comprises not just military activity, but the friendly invasion of neighboring towns and tourists. (Courtesy of Geri Gray.)

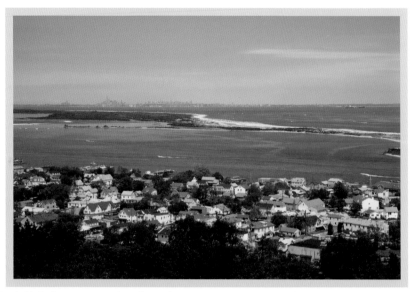

Highlands has had a great view of Sandy Hook since the beginning of time. The photograph below was probably taken from the Twin Lights of Navesink in 1926. Sometimes, soldiers would visit Highlands for entertainment or visit Highland Beach Resort, across the Shrewsbury River on the southern end of Sandy Hook. (Past image, courtesy of Walt Guenther; present image, courtesy of Les Horner.)

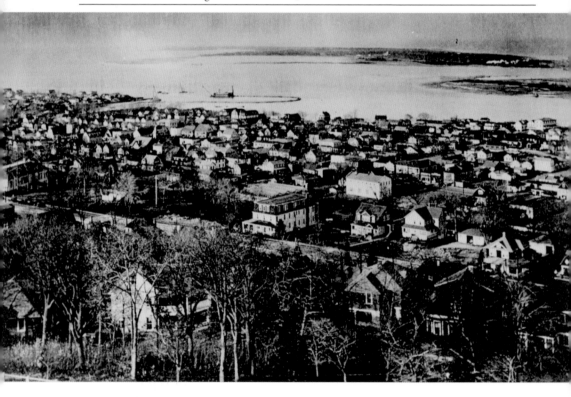

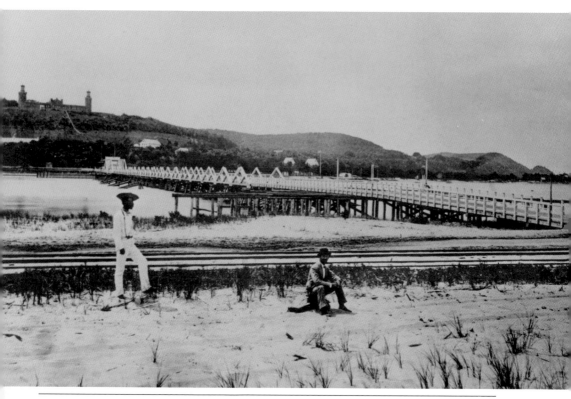

Seen above, the first bridge to cross the Shrewsbury River was a wooden structure built in 1872 for $35,000. It lasted only a few years, so a second bridge opened in 1878 and lasted until 1933, when it was replaced by the so-called "Million Dollar Bridge." Today, the newest bridge is called the Capt. Joseph Azzolina Memorial Bridge, named in honor of the longtime New Jersey state legislator and US Navy officer. (Past image, courtesy of Walt Guenther; present image, author photograph.)

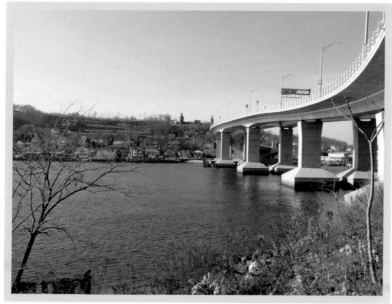

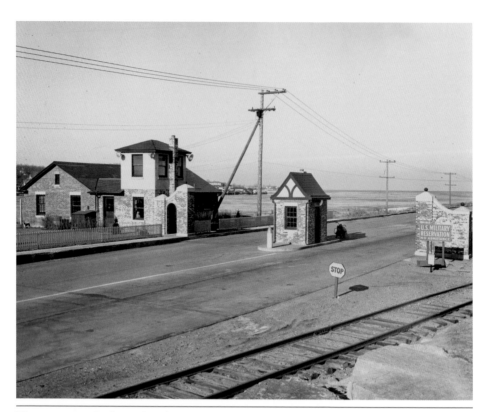

The entrance to Sandy Hook and Fort Hancock has been somewhat consistent during the past two centuries. The above photograph shows the main entrance to the fort in the early 1940s along with the small building with the two-story "watchtower," which still stands today near the entrance to the Sandy Hook Unit of the Gateway National Recreation Area. (Past image, courtesy of GATE; present image, courtesy of Geri Gray.)

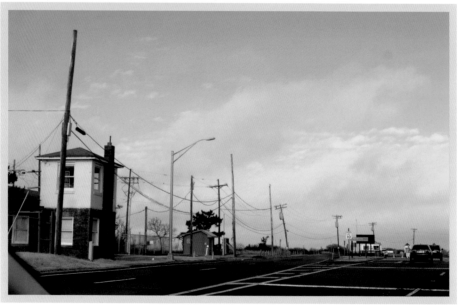

CIVILIANS, VISITORS, AND TOURISTS

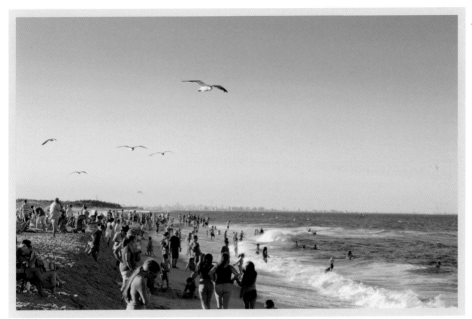

Beachgoers have enjoyed frolicking in the Atlantic Ocean and playing in the sand for centuries. Pictured below, Wardell's Beach, as it was called, was part of the Highland Beach Resort. The resort offered ocean and river swimming, boating and fishing, a restaurant and nightclub, a movie theater, roller-coaster and merry-go-round, a hotel, bathhouses, and private cottages. Most of the buildings were in the Victorian style, and access to the resort could be had by train, boat, or auto. Today, more than seven miles of beaches on Sandy Hook make the area a popular tourist destination. (Past image, courtesy of Susan Gardiner; present image, courtesy of Alamy Stock Images.)

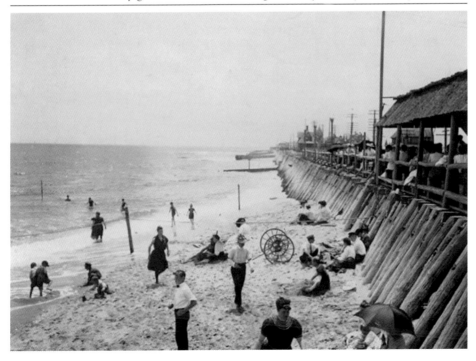

DISCOVER THOUSANDS OF LOCAL HISTORY BOOKS
FEATURING MILLIONS OF VINTAGE IMAGES

Arcadia Publishing, the leading local history publisher in the United States, is committed to making history accessible and meaningful through publishing books that celebrate and preserve the heritage of America's people and places.

Find more books like this at
www.arcadiapublishing.com

Search for your hometown history, your old stomping grounds, and even your favorite sports team.